Alutiiq Museum & Archaeological Repository
Kodiak, Alaska

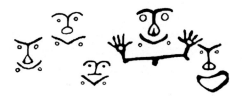

A L A S K A
HUMANITIES
F O R U M

This project was supported in part
by a grant from the
Alaska Humanities Forum
and the
National Endowment for the Humanities,
a federal agency.

From the Old People

THE CAPE ALITAK
PETROGLYPHS

Llirluni cuuliraq suuíut cingiyaq Alitak patriitaq

Quliyanguaq
Woody Knebel

umyaaqlluku
cuulihaq suu'ut
kiman
anerneq
unguwaluni ngiikiaqlluku
ilua yaamaq
culurlluni
cali
anerneq lla

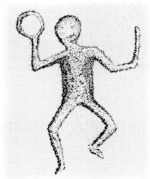

Dedicated to the
Old People
whose
Presence
lives on in the rock
the land
and
the
spirit world

Steve Mull, General Manager
Barbara Bolton, Project Director
Anne Cordray, Researcher
Barbara B. Buchanan, Assistant General Manager
Jan Martin, Editorial Production Coordinator
Marsahll McClure, Design Production Coordinator
Richard A. Horwege, Senior Editor
Elizabeth Bobbitt, Editor/Designer
Scott Rule, Director of Marketing
Travis Gallup, Marketing Assistant

Library of Congress Cataloging-in-Publication Data

Knebel, Woody, 1956-
 The Cape Alitak petroglyphs / by Woody Knebel.
 p. cm.
Includes bibliographical references and index.
 ISBN 1-57864-212-4 (alk. paper)
 1. Paleo-Indian--Alaska--Alitak Bay Region--Antiquities. 2. Petroglyphs--Alaska--Alitak Bay Region. 3. Alitak Bay Region (Alaska)--Antiquities. I. Title.
 E78.A3.K54 2003
 979.8'4--dc21

 2003005393

 Printed in the United States of America

C O N T E N T S

Imaq

F O R E W O R D

Woody Knebel's study of Alutiiq petroglyphs—*From the Old People: The Cape Alitak Petroglyphs*—is the first volume of the Alutiiq Museum Papers, a series of publications dedicated to sharing Alutiiq heritage with a broad audience, both popular and scientific. Much of the written record of Alutiiq history is buried in academic journals, archival documents, and obscure publications that are difficult for most people to find. In response to the growing interest in Alutiiq traditions, and to support the museum's mission of promoting knowledge of the Alutiiq, we established this publication series. We believe that it will provide our patrons with a way to continue learning about the Alutiiq. It will also give researchers access to new information and help authors bring deserving works to publication.

Through this powerful, lasting format, we will encourage different voices to share their knowledge of Alutiiq heritage and educate the world about who we are. Knebel's petroglyph study is a fitting start to our new publication series. Prehistoric rock art is a popular topic, one that has captured the imagination of many in the Kodiak region. Why did Native people peck images into stone? How old is this art form? What do these images mean and what do they tell us about past societies? Visitors to the Alutiiq Museum frequently ask about petroglyphs, children recreate these images in school project, and artists incorporate these ancient graphics into contemporary works. Yet, despite their enormous popularity, Kodiak's rock carvings have never been comprehensively inventoried or studied. There is relatively little known about these rare works of prehistoric art. Petroglyphs are well recorded in southeast Alaska, where the Tlingit Indians used them as territorial markers—symbols of a clan's traditionally used harvesting areas (de Laguna in Emmons 1991, 78; Kan 1989, 56). However, they are uncommon in other Alaskan coastal settings. Archaeologists report only a handfull of stationary rock carvings in all of western and northern Alaska (Pratt 1992). In contrast, there are at least seven known petroglyph localities along the coast of the Kodiak Archipelago. This makes the Kodiak glyphs particularly special.

Knebel's synthesis, which focuses on the Cape Alitak petroglyph cluster, is the result of more than ten years of drawing, photographing, and experiencing the mysteries of this windswept place at the southern entrance to the Kodiak Archipelago. His work sheds important light on Kodiak rock art. The Alitak glyphs are the largest known cluster of stationary rock carvings in the region with well over five hundred individual images. As such, they provide an unusually rich picture of Alutiiq artistic conventions, the traditional symbolic repertoire, and for those who look closely, the spiritual beliefs of Alutiiq ancestors. Moreover, they provide an important comparison to the many other forms of Alutiiq artistic expression preserved in artifacts and historic objects. There is still much to be learned from the petroglyphs, and Knebel's synthesis now makes them broadly available for study, interpretation, and artistic inspiration. *Quyanaasinaq,* Woody, for creating such a wonderful book.

Finally, petroglyphs are a relevant topic, as they are a source of cultural pride. This became particularly evident in the work with the community of Akhiok to document the Alitak images. Equipped with sheets of clear plastic and magic markers, students from Akhiok School carefully traced hundreds of these large carvings to create full-sized replicas of the images. Working in the drizzle, on their hands and knees, these children created a lasting record of their ancestors' world. This is critical work. The glyphs are fading with time. They are being reclaimed by the sea, wearing away gradually with each high tide. They are also threatened by their increasing notoriety. Vandals have already tried to remove at least one set of Afognak Island images from their ancient perch with a chain saw. Fortunately, they failed. The value of documenting the glyphs, however, was much deeper than simply recording each image. Drawing the faces, animal forms, and characters at Cape Alitak brought all of us closer to their creators. They linked us to those who used the land before and instilled us with a sense of endurance. The petroglyphs are a symbol of persistence. We have survived the storms of the past and are as firmly fixed to our homeland as our ancestor's images are anchored to the island's bedrock.

SVEN HAAKANSON JR., Ph.D.
Executive Director
Alutiiq Museum & Archaeological
Repository

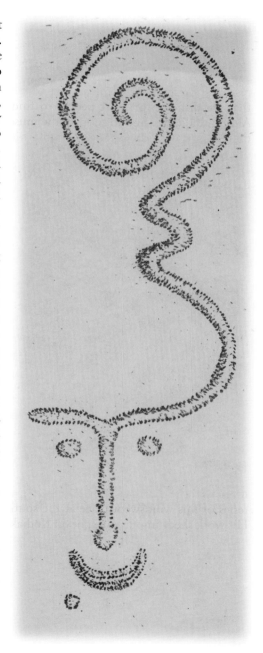

7

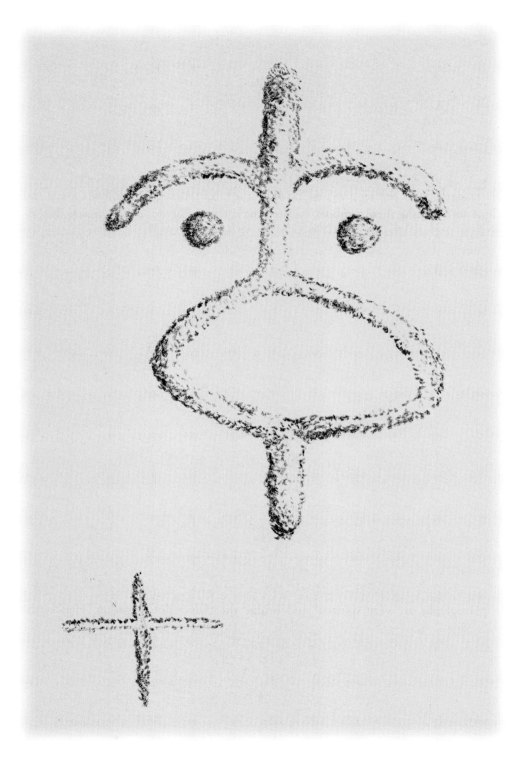

PREFACE

Aularnirluni

When I initially made the decision to document the Cape Alitak petroglyphs on the southwest end of Kodiak Island, I was quite naive as to the significance of this endeavor. My first visit to the petroglyphs was in the summer of 1990, when I saw one of the several sites I would later study. Intrigued by the craftsmanship and mystique surrounding these symbols, I visited the site faithfully for over a decade. It wasn't until eight years after my initial contact that I gave any serious consideration to documenting and sharing my account regarding these works in stone. Whether it was the intent of local Native people who gathered at this (in my opinion) sacred site for the transmission of their beliefs and intervention with their spirits, I felt this site deserved to be documented in a systematic way to both preserve and share this knowledge.

*umyaaqlluku
aularnirluni
cama'I
allakaq litnaurluni
caqiq petroglyph
aprun kula'irluni macaq
qai-cali Kodiak qikkertaq?
cingiyaq Alitak patriitaq
kalla'alek
akirluni enwia
nangarlluni keslin yaamaq
takuka'aq cingiyaq
quliyanquaq
quiliraulluku
iqukllilluni
tukniluni
iingalaq takuka'aq*

From time on there has been a mystique with the carved symbol. Dating back from the most recent era to several thousands of years, petroglyphs are found throughout the world. "Man throughout the ages and in all regions has shown a desire to perpetuate the history of the past and to record the story of his life. A direct result of his surroundings, he employs pictures, carvings and structures to illustrate and transmit his traditions, genealogy and pursuits" (Emmons 1908, 219). An image carved or pecked into a rock face by stone tools is called a petroglyph and is an ancient art form used by many cultures. Of the numerous sites known worldwide, the one unifying element has been to render images of animals, geometric forms, humans in various acts, and possibly spirits into reality. Whether such rock art was used as the link to that unseen spirit world is up to one's personal interpretations. In my opinion these petroglyphs are very spiritual and bridge the two realms together. Hence, the carved image.

Art is defined as the conscious use of skill and creative imagination, especially in the production of aesthetic objects; also, the skill acquired by experience, study, or observation (Webster 1979, 62). Was it the study and observation of the resources that humans relied on, and the experience of total integration with the surrounding world that led the people to render into stone such images? "Art in itself rarely transmits useful information, but depicts human emotions almost exclusively. Symbols, however, represent specific

meanings within a language framework that have regionally broad application and cultural interpretation" (Fearing 1975, 3). The unevenness of this granite, and the energetic work required to bring an image into being on such a tough medium, demonstrates the people's desire to either appease the spiritual world or show the living world their respect for all things. Did they understand that in order to survive in the living world they must both conciliate and exploit the spirit world?

Cape Alitak is the largest concentration of petroglyphs known in the western and northernmost boundary of the Pacific Northwest. It is within the aboriginal territory of the Alutiiq at Cape Alitak on Kodiak Island, Alaska. Cape Alitak is a testament to the rich mythic and spiritual heritage of Kodiak Island.

Petroglyphs are illustrations in rocks, and we do not know, nor can we directly say, what they signified or meant. "Since they are not writing, they cannot be 'read' even though they may refer to stories, which were once known verbally. We can only guess at their meaning" (Abbott 1974, 7). Given this, my goal was to document the images and study them. Because no one has seriously published these images, I wanted to develop a document as an educational resource for the Alutiiq people. By shedding light on this important site, I hope to help in preserving a past form of communication.

In the course of action over the last few centuries, with the spread of Europeans across the world, the Alutiiq people would have their world, as they knew it, torn from their grasp. Brutalized, murdered, cheated, and prohibited from speaking and practicing their native ways, many of their customs disappeared. As I delved into the history of these original settlers of Kodiak Island, I was impressed by their resilience and ingenuity in maintaining—what outsiders thought was gone—their traditional values. Through all the hardships, the peoples of the Kodiak Archipelago have maintained their identity and dignity.

The timing of the awakening or rebirth of these ancient symbols follows a pattern of self-discovery of their history and is another link in the bridge to reconnect this generation to its heritage. It is my belief this project effectively embraces the resurgence of cultural dignity and complements the current state of Alaska humanities theme of "Strengthening Community—Exploring for Meaning" (Alaska Humanities Forum 1998, 5).

Before I go into my findings, I want to establish that I am not trained in an anthropological fashion, merely a student of the natural environment learning and discovering the past and sharing this with you. I researched anthropological and non-anthropological resources to guide my path. Any inaccuracies or interpretations are mine, and I accept full accountability for them.

I would like to acknowledge that this project was supported in part by a grant from the Alaska Humanities Forum and the National Endowment for the Humanities, a federal agency. "Its mission is to use the wisdom and methods of the humanities to promote the civic, intellectual, and cultural life of all Alaskans. The logo of the Alaska Humanities Forum *[seen on page one]* combines a prominent artifact of Western civilization, a draw-

ing by Leonardo da Vinci, with a prominent artifact from Eskimo civilization, an ivory carving from the Okvik period. Together, they symbolize the complex mix of cultures that make up our Alaska heritage, reminding us not only of our differences, but of the unity and validity of the various humanities traditions of Alaska's people" (Alaska Humanities Forum 2000, 3).

"Ling'ayugluni quyanaasinaq" to the Native Councils of Kodiak for their support and kind words of encouragement. By granting permission to walk the land of their ancestors, they have enabled me to assimilate the raw data and bring forth my interpretation of these icons of a past civilization. They include Akhiok-Kaguyak Inc., Natives of Kodiak, Old Harbor Native Corporation, and Kodiak Tribal Council representing the Shoonaq' Tribe, Larsen Bay, Port Lions, Ouzinkie, Karluk, and the Native Village of Afognak.

"Amlesqat quyanaasinaq" to Dr. Sven Haakanson Jr. of the Alutiiq Museum and Archaeological Repository in Kodiak for allowing access to the museum's collections, and enabling me to appreciate the rich tapestry of an earlier culture. Also for evaluating and drafting my manuscript for authenticity. *"Gwi quyaklluku"* to Alixe Wallis, whose unique graphic interpretations portrayed the ever-changing mood of the symbols. Combining my photographs and field rubbings, Alixe metaphorically breathed life into the spirits in the stone, as is evident in the graphics throughout this manuscript.

Since the 1930s anthropologists have been researching the regional archeological record that extends 7,500+ years into the prehistoric past of the Alutiiq. I reference their shared knowledge with appreciation. Many thanks to Dr. Donald Clark for his contributions and his lifelong dedication to this field of study.

At the onset of this project, I had a premonition of phenomenal events taking place. Hoping to experience some of the mystique surrounding these historical treasures, I approached the mechanics of scientific research with the spirituality of the heart. "The only ingredient necessary to read the energy of the carvings is an open heart and a willingness to listen with an open mind" (Inglis 1998, 104). The "Old People" certainly did not let me down. The first time I approached the collecting of data in earnest, I had an enormous energy pass through me, saw visions and felt the presence of others (see Appendix II). Even after being charged by a Kodiak brown bear on the way to the Goldmine site (see Appendix III), I firmly felt that the "Old Ones" were instrumental in sharing with me some of their secrets. I consistently had the feeling they were encouraging me to tell their story. Why else would a thousand pounds of raw energy stop short of me and turn tail? I realize now as I put these words to pen that the presence I felt after the bear suddenly stopped and ran away was not what I believed to be a larger bear behind me or my enigmatic presence, but the collective spirits of the "Old People."

Research is a solitary path and at the sites, I chose to do most of the work by myself, because of the connection I personally felt to the area. Others accompanied me at times, but the spirits were quiet and shared glimpses of their story only when I was alone. There is a great mingling of energies in and around these locations. I have gained a personal sense of satisfaction from this project. In part because it shares my knowledge with new

audiences and in part for enabling me to look beyond the landscape and hear the harmony intertwined with the vastness of this great land. I have experienced and learned to see the boundless beauty of peace and solitude embodied within nature. The interconnection with nature that people in the past felt comes only from recognizing the total integration of nature and our dependence on the powerful spirits of the universe.

I spent a weekend with the Akhiok-Kaguyak High School class and the director of the Alutiiq Museum mapping out some of the carvings. It was a unique experience to be standing on the same ground that the ancient carvers stood on, breathing the same air, and feeling the spray from the ocean on my face alongside their ancestors. When I showed some of my sketches, one young boy started to interpret them as if he were an elder. A great compliment was bestowed upon me. I was told that my work came from my *"unguan"* (heart).

From the mud flats of Bristol Bay to the sheltered inlets of Baranof Island, from the jungles of South America to the prairies of Alberta, and from the rain forests of British Columbia to the fjords of Kodiak Island, I have lived and labored side by side my entire life with the indigenous peoples of these regions. It is an honor to share my work with them.

At the age of twelve, while paddling an old cedar canoe in the sheltered waters of Cordova Bay on the south end of Vancouver Island, I encountered a gray whale and her calf. The three of us shadowed each other for more than an hour in the shallow kelp beds of the bay. Two distinct species crossing paths, suspended for a moment in time. A moment that would form a lifetime bond. It was a defining instant in my life that collectively focused all my senses and charted a life's course of adventure and the desire to understand the workings of nature. How profound that course would pilot me to the south end of Kodiak Island and place me directly on the aboriginal lands of the Alutiiq people and their ancestors, the authors of the Cape Alitak petroglyphs.

Even more inspirational are the carvings of the great whales that continue to fascinate me to this day. I have spent time watching the great whales from a modern bidarka for many years. During that time, I have dived with Killer whales and Beluga whales, of which both are depicted in the carvings. In writing this book on a past civilization's "soul of communication," it is here that the course set decades earlier has come to fruition.

I believe in this project; I am Alaskan born. I have been placed in this unique environment for a reason, and I have a sincere and respectful desire to preserve and try to understand why those that passed before us left signs and messages in the stone.

Ling'ayugluni,

—WOODY KNEBEL

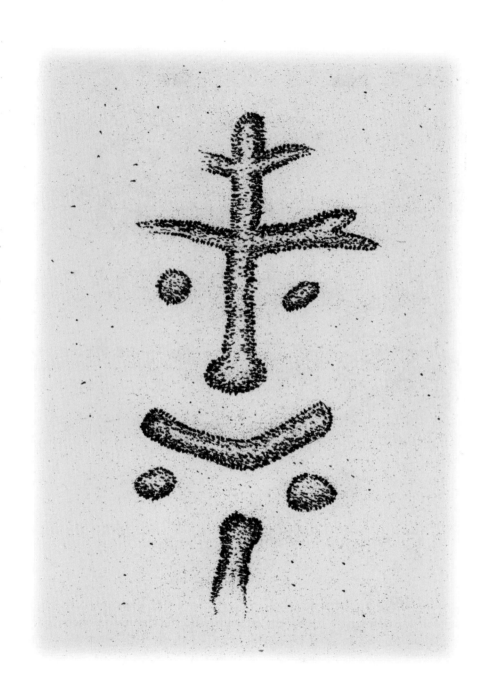

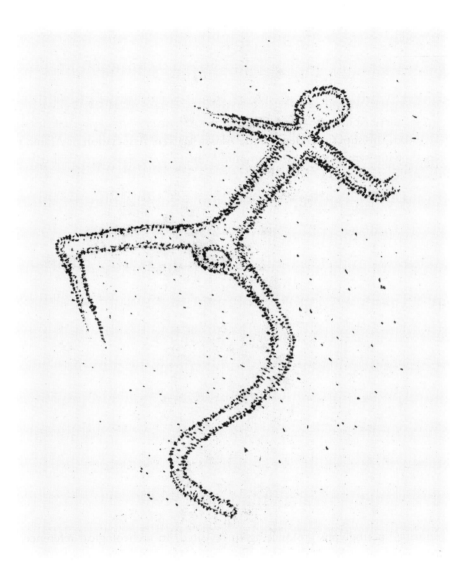

INTRODUCTION

Cama'i

Greetings

Eight decades ago a brief note on the "remarkable" petroglyphs at Cape Alitak on the southwest side of Kodiak Island appeared in the *American Anthropologist*. Captain C. A. Halvorsen, the superintendent of the Alaska Packers Association at Alitak, took photographs showing symbols cut in the granite formations of the cape. Although most of the figures were quite distinct, time had shown its action, and in order to strengthen them in film, they were painted over and chalked. The year was 1917. A decade later, Dr. Aleš Hrdlička, the director of the Division of Physical Anthropology of the United States National Museum, was commissioned under the auspices of the Smithsonian Institution to undertake a systematic anthropological survey of Alaska. This fieldwork involved ten seasons, seven and a half of which were focused on Kodiak Island and the Aleutian Islands. While on Kodiak Island, Mr. Foster, the owner of the salmon cannery at Lazy Bay, took Dr. Hrdlička up Rodman Reach to visit "a blunt point opposite Tanner Head and the Alitak Cape, 'famed locally' for its petroglyphs." The year was 1932.

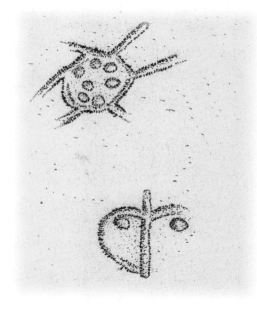

A decade later Dr. Robert Heizer, a former student of, and expanding upon, Hrdlička's work, released a more in-depth synopsis of "the decisive, sure and clean cut" Cape Alitak petroglyphs in the proceedings of the American Philosophical Society. The year was 1947. Now, a half-century later, on the cusp of the new millennium, Cape Alitak's "enduring" petroglyphs are once again revisited. In archeological reference, the past century is but a mere breaking of a wave in time. Like other treasures left by those that came before us, the designs are exposed to time and the elements. Earthquakes, rain, wind, high tides, and storm water continually wash over them. Although erosion is an ongoing process, the semipermanence of stone provides a rare opportunity to look back hundreds, perhaps thousands, of years and be able to share a common experience with and a gift "From The Old People."

Llirluni cuuliraq suuíut

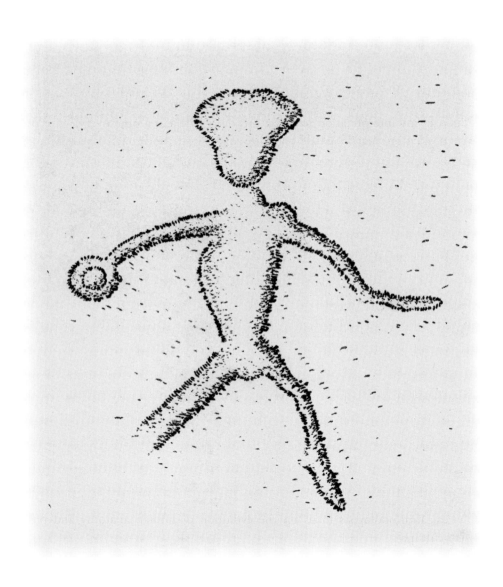

CHAPTER I

Allakaq litnaurluni

The Different Disciplines

I have used historical, anthropological data throughout this manuscript. Since much of the foundation of my interpretation relies on this data, I believe a brief overview of the disciplines involved is prudent. The field of anthropology is the study of all aspects of human life and culture. It examines how people live, what they think, what they produce, and how they interact with their environment. Anthropologists try to understand the full range of human diversity as well as what all people share in common. Anthropologists generally specialize in one of four subfields: cultural anthropology, linguistic anthropology, archaeology, and physical anthropology.

Cultural anthropology refers to the ways of life learned and shared by people in social groups. Culture is fundamentally tied to people's ability to use language and other symbolic forms of representation, such as art, to create and communicate complex thoughts. Symbolic representation allows people to pass a great amount of knowledge from one generation to another. People use symbols to give meaning to everything around them, every thought, and every kind of human interaction.

Linguistic anthropology focuses on how people use language in particular cultures. Linguistic anthropologists often work with people who have unwritten (purely spoken, or oral) languages or with languages that very few people speak. Archaeology focuses on the study of past, rather than living, human societies and culture. Most archaeologists study artifacts (the remains of items made by past humans, such as tools, pottery, and living structures) and human fossils (preserved bones). They also examine past environments to understand how natural forces, such as climate and available food, shaped the development of human culture.

Physical anthropology concentrates on the connections between human biology and culture. Physical anthropologists focus on the evolution of human anatomy and physiology rather than culture.

Most anthropologists believe that an understanding of human evolution explains much about people's biology and culture. Biological evolution is the natural process by which new and more complex organisms develop over time. Humans have changed little biologically for the past 100,000 years. On the other hand, today's worldwide culture, characterized by the rapid movement of people and ideas throughout the world, is only a few hundred years old. Today's global-scale culture differs vastly from that of the small-scale societies (nonindustrialized) with small populations in which our ancestors lived for hundreds of thousands of years.

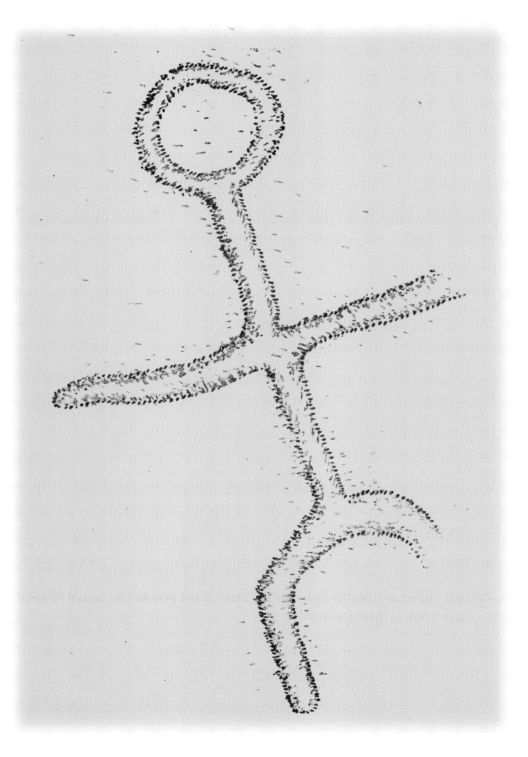

C H A P T E R 2

Caqiq yaamaq patriitaq?

What Is a Petroglyph?

PETROGLYPH (Greek): *Petro* = stone and *glyph* = carving an inscription cut into the face of a cliff or rock; especially a prehistoric carving of this kind (*Webster's New Twentieth Century Dictionary Unabridged 2nd Edition* 1966).

The word comes from two roots, *petro*—Latin for rock or stone, and also the root of "petrology" (the study of rocks), and "petrified" (to turn into rock). *Glyph*—Latin for "writing" or "symbol." *Glyph* is the root for "hieroglyphics," the ancient Egyptian symbolic written language, and the modern "glyph" meaning a little mark.

To the ancient carver, the meaning went far beyond the description found in a dictionary. These are symbols that were perhaps tied to significant events or spiritual guardians. Generally, it is believed shamans created the petroglyphs to increase hunting prowess, to enhance shamanistic powers, and to commemorate hunts, raids, or successful vision quests and other religious rituals.

Without the use of words or sounds or any other form of language, rock art conveys visions and stories to the mind. It is the only type of artifact that required the maker to observe the environmental process, assimilate the information through his mind, and then express it in any shape or form he desired (Keyser 1998, 2). Throughout time the "Old Ones" transferred their spirit in a multitude of fashions, and rock art was one of the most intriguing forms. It is the only artifact that lets us look into the mind of the person who creates it. Rock art was a direct link to the spirit world.

> pet-ra-glif (noun):
> Cultural writings and symbols inscribed on rock or clay.
> An ancient art form used by many cultures as a means of personal expression and tribal identity.

Although some feel it is a mistake to refer to petroglyphs as "rock art" on the premise that the development of any kind of art form is heavily dependent on a single cultural element: leisure time for an individual to design, develop, and produce his symbolic representations. This cultural icon can only be met when a society has become affluent enough in terms of procurement of food and shelter to enable art-inventing adults to dispense with a hunting-fishing-gathering economy so as to be able to devote their time to

"art." However, the one caveat is the cultures, such as the arctic Eskimo and the Alutiiq, where the variations of climate provide enforced leisure and time to create art.

It may seem more appropriate to think of these enigmatic drawings as a form of language communication, each separate image a linguistic symbol that is a precursor to the development of alphabetic writing. Behind each symbolic representation there must be a logical reason and a specific meaning within a language framework.

Regardless of this particular viewpoint and in acknowledgement to such, I will refer to the symbols throughout this document interchangeably with the term "rock art."

Ugauluni qangirllaq yaamaq picingluni

Types of Ancient Rock Art

PETROGLYPHS are man-made images that were abraded, carved, incised, pecked, or scraped into a rock face using crude tools (other stones). Such tools were made from wood, bone, and stone. By pecking away at the surface of the stone, they exposed the lighter colored rock below. Petroglyphs are most often found on darker rocks covered with a *patina* (a film that covers rock over time). The patina provides the perfect surface for the petroglyphs. *Anthropomorphic* (human-like) and *zoomorphic* (animal and bird) images are common, as are geometric and *azoic* (circles, spirals, dots, lines and other abstract forms) symbols. They are typically found on boulders and bedrock outcroppings on the shores of rivers, lakes, and oceans—if not above or below mean high tide, then overlooking and facing towards the water. The three rocks most frequently used are sandstone, volcanic basalt, and granite.

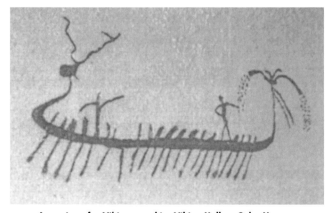

A carving of a Viking warship, Viking Hallen, Oslo, Norway

Dating back from a few hundred to several thousands of years, petroglyphs are found all over the world with the exception of Antarctica—often with similar symbols and design elements showing up on different continents. Petroglyphs are unique in the fact that they are artifacts that have not been removed from their original locations.

Washed by the Pacific tides, the North American contingent of symbols begin abruptly on the south end of Kodiak Island. This could lead one to postulate that Kodiak was a transitional point between the Far East and the Pacific Northwest. Travelling down through southeast Alaska and into British Columbia (where there is a profusion of styles and sites in and around Vancouver Island), they continue along the lower Columbia River separating Washington and Oregon and work their way through the rest of the states.

ROCK VARNISH is a substance that forms over time on rocks causing darkening of the color of the rock surface. One of the most remarkable bio-geochemical phenomena, microscopic organisms residing on the rock's surface secrete a substance that causes airborne specks of certain minerals to stick to the rock. Over long periods of time, as the varnish accumulates over the petroglyphs too, the petroglyph can become as dark as the rock, sometimes leaving it very hard to see in contrast to the surrounding natural coloration of the rock.

PICTOGRAPHS (pictoglyphs) are images that are drawn or painted on a rock face, normally without any pecking or abrasive methods. Using natural pigments, the paints were typically made from pulverized mineral earths like haematite, or red ocher, an anhydrous iron oxide (Fe_2O_3).

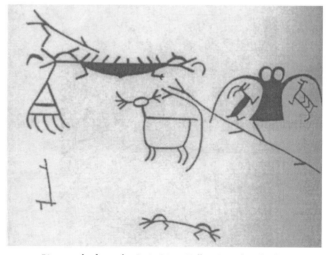

Pictographs from the Stein River Valley, British Columbia

Red, white, and black are the most common colors. Designs are painted on rock by mixing the powdered minerals with grease, blood, charcoal, saliva, salmon eggs, clay or other substances. Pictographs are most often found in sheltered rock overhangs or caves high above the water's edge, where they are protected from the weather.

HIEROGLYPHS—The word comes from a Greek term meaning "sacred carving," which the ancient Greeks used to describe decorative characters carved on Egyptian monuments. They refer to characters in any system of writing in which symbols represent objects (such as tools, animals, or boats) and ideas (such as motion, time, and joy). The term is now mainly used to refer to the system of writing used by the ancient Egyptians.

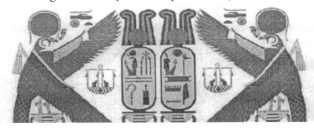

Egyptian hieroglyphs

Consisting of several hundred picture-signs, these signs were divided into two classes: phonograms and ideograms. *Phonograms* were signs used to write the sounds. *Ideograms* were idea-signs, in which each picture stands for the object represented, or for some idea closely connected with the object. Most words were written using a combination of both. Archaeological discoveries suggest that Egyptian hieroglyphs may be the oldest form of writing. The earliest evidence of an Egyptian hieroglyphic system is believed to be from about 3300 or 3200 B.C.

SOLAR MARKERS—Carvings that mark an event by the light falling directly on them. These are known as indirect solar markers. Symbols have been found at locations where the sunrise would be seen in a notch in the distant mountains on a special day. These are known as direct solar markers.

GEOGLYPHS—(itaglios) Images formed on the ground. Typically, surface matter was scraped away to form an image in the exposed, underlying soil or by arranging stones to form an image. Geoglyphs are commonly known as earth-figures and are the most fragile rock art. They are among the most impenetrable enigmas of archaeology by virtue of the quantity, nature, and size, as well as their continuity. Some geoglyphs depict living creatures, plants, or imaginary figures, as well as geometric figures several kilometers long. They are believed to have had ritual functions connected with astronomy.

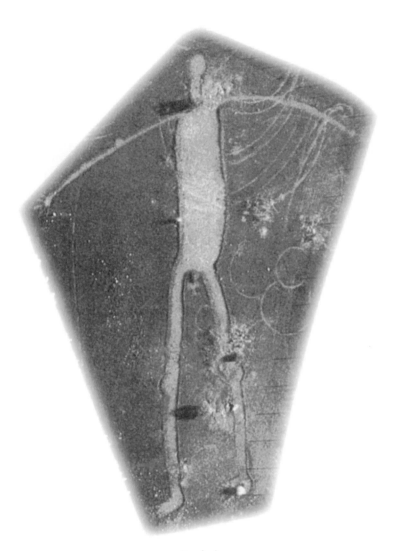

Geoglyph

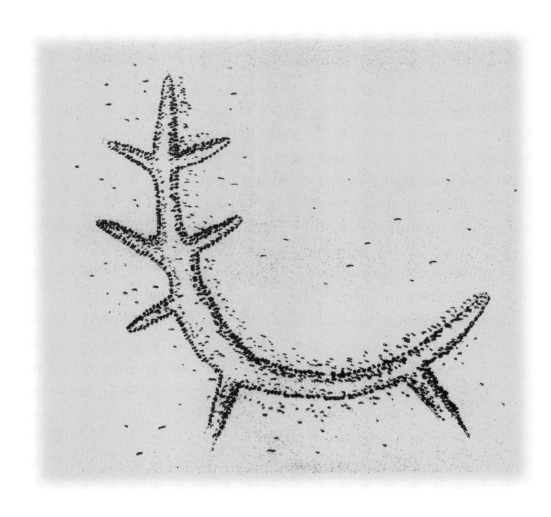

24

C H A P T E R 3

Aprun kula'irluni macaq

The Road Towards the Sun

A result of its unique geographic position, Alaska is vitally significant to American prehistory; not just for the early settlement of the continent but also as the land through which later waves of immigration passed (Hrdlička 1944, 5). The origin of the state's name is based on the Aleut word *alaxsxaq* or *agunalaksh,* literally meaning "object towards which the action of the sea is directed" or, more simply, "great land." With license of free prose, the early explorer's loose translation could be "where the sea breaks its back."

> "That as long as the road to the south, 'towards the sun,' was free they were under no necessity of establishing any permanent settlements in the north; and that the direction of least resistance and better prospects, two of the main laws that control all human migratory movements, was not through the difficult and largely inhospitable Alaskan mainland, but along the much easier coasts southward."
> —Aleš Hrdlička 1932, 1

The state stretches from the rainy and forested Pacific Northwest to the arid and treeless Arctic Coastal Plain. One-third of the state lies within the Arctic Circle and has perennially frozen ground (permafrost) and treeless tundra. This "object" is surrounded by water on three sides and has a coastline extending over 6,500 miles. The entire coastline, taking into account the thousands of bays, fjords, and islands, has been estimated at approximately 33,000 miles. The Alaska region encompasses an estimated 656,425 square miles of land spread over close to 20 degrees of latitude. It does not border any other states but has the Arctic Ocean on the north, Canada on the east, the Gulf of Alaska and the Pacific Ocean in the south, and the Bering Strait in the west. Of the twenty highest peaks in the United States, seventeen are located in Alaska. At 20,320 feet above sea level, Mt. McKinley (originally *Denali*), located in the interior, is the highest point in North America. The cultural complexity and diversity represented in the archeological record can be partly attributed to the vast size and the varied environments of Alaska.

During the Pleistocene Epoch, which occurred between 1.65 million and 10,000 years ago, there was a period of intense cold. About one-third of the way into the Pleistocene, the first Ice Age hit. There ensued a series of advances and retreats throughout this period, where glaciers repeatedly rolled across North America bringing about tremendous ecological and topological change. Four distinct periods of glaciation occurred. The final onslaught of ice, known as the late Wisconsin glacial episode, occurred around 12 to 15,000 years ago when the continents of Eurasia and North America were geographically linked.

Close to 70 percent of the earth's surface is covered by a layer of water. The hydrosphere consists of the oceans, water in lakes and streams, subsurface water, the ice of glaciers, and the water vapor in the atmosphere. Known as the hydrologic cycle, water in many forms is in constant motion. During extended cold periods, tremendous vol-

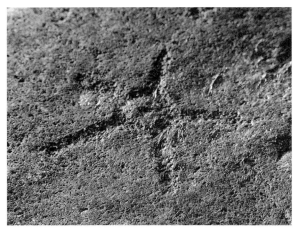

umes of water were deposited on land in the form of ice and snow. Because the amount of water in the Earth's hydrosphere is constant, and so much of the global water supply was locked up in huge ice masses, the sea level fell 280 to 350 feet below today's level.

The Bering Strait is a relatively shallow body of water linking the Arctic Ocean with the Bering Sea and separating the continents of Asia and North America. It has been postulated that the Bering Strait must have been the source of ethnic connection between the two continents (Boa 1896, 14). It is named after Vitus Bering, a Danish sea captain who had served in the tsar's navy since he was twenty-three. He piloted the *St. Gabriel* through the strait in 1728, and concluded that Asia and America were not joined. However, in his efforts, he failed to see the fog-shrouded Alaska mainland on this voyage. Thirteen years later, under a commission from the Russian government, he would command the *St. Peter* on a second voyage to substantiate his earlier claims. At the helm of the *St. Paul* and second in command was Alesksei Chirikov, whom Chirikof Island (80 miles distance from the petroglyphs) in the Gulf of Alaska was named for. This isolated island would eventually become a Russian penal colony, according to popular folklore, for harvesting ground squirrels and today is home to 1,000 head of feral cattle. Also of significance onboard the *St. Peter* was Georg Steller, a German naturalist whose field work is still referenced today by such species as the Steller's sea lion, Steller's sea cow, and Steller's jay.

Through a series of misfortunes, twenty men died, including Bering, when the *St. Peter,* on the way home after only six months, ran aground on a rocky island off the Siberian coast. Although Bering's voyage ended in disaster, the remaining crew was able to build a 40-foot boat out of the wreckage, and they returned that following spring with enough sea otter pelts they had collected on the main voyage to cause a rush of entrants into the fur trade in Alaska. Bering's voyage not only laid the basis for Russian claims to Alaska but also opened the fur trade.

During Bering's first exploration in 1741, soundings of the Bering Strait ranged from 98 to 164 feet in depth. The distance between Siberia and Alaska's Seward Peninsula is approximately 55 miles. However, during many periods of the Pleistocene ice ages, the trip could be made entirely on land.

Shallow submarine plains that border many continents and typically end in deep slopes to an oceanic abyss are known as continental shelves. Where a wide continental shelf slopes gradually, a small drop in sea level can increase shoreline areas greatly. This build-up of the global water supply exposed vast areas of land formerly under water and created a 1,000-mile-wide grassland steppe consisting of level, generally treeless plains. Because animals from the two sides were able to migrate between Eurasia and the Americas when Beringia was above sea level, it is also called the Bering Land Bridge—linking a part of Asia physically and ecologically with the Alaska mainland. This land bridge appeared and disappeared many times. It also separated the Bering Sea to the south and the Chukchi Sea to the north.

The Beringian Oecumene is an ensemble of related peoples integrated by trade, migration, warfare, and the cross-fertilization of ideas, oral traditions, and art into a large cultural universe (Fitzhugh, Crowell 1988, 12).

Most early human populations of the Americas are descended from the peoples who lived in Beringia and, over the course of generations, "crossed" Beringia. It is theoretically possible that people could have entered North America from Asia at repeated intervals between 40,000 and 13,000 years ago. The late Pleistocene and early Holocene Epochs provide a record of the first entries of humans into the Americas and, consequently, they are associated with one of the great migratory events of human history—the peopling of the New World.

North America was one of the last continents to become peopled, because it was separated from other continents by vast oceans. It is generally accepted that the New World was settled by immigrants from Siberia and northeast Asia. Whether on land, along Bering Sea coasts, or across seasonal ice, humans crossed Beringia from Asia to enter

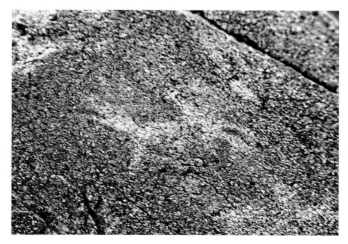

North America about 13,000 or more years ago. Humans were latecomers to this magnificent landmass. Europe, the Middle East, Asia, the Indonesian Archipelago, and Australia already hosted humans.

Cultures of northeastern Siberia are represented by four groups:
1. The southwesternmost is a composite of Chinese- and Japanese-influenced cultures (Gilyak, Nanai, and others) living along the lower Amur River and nearby maritime regions.
2. Even (formerly called Lamut), a reindeer-herding culture living west of the Sea of Okhotsk.
3. Koryak and Itelmen (Kamchadal) and adjacent maritime regions.
4. Chukchi, farthest to the north, who like the Koryak were divided between reindeer breeders on the interior and maritime sea mammal hunters on the coast.

North American cultures in Alaska are represented by four groups:
1. Eskimo, primarily a coastal people, settling along the shores of the Arctic and Bering Seas. They lived a simple subsistence life by harvesting the fish and mammals of the sea, the flora and fauna of the land.
2. Aleut, a life centered around the sea. They settled amongst the myriad of islands in the Aleutian chain across the North Pacific. Their food supply was rich, varied, and readily available, which enabled them time to develop a complex culture.
3. Athabascan, known as nomads of the interior, were skilled hunters depending on large land animals for their subsistence. They followed the migrating caribou and hunted the moose. Ingenious fishermen, they snared fish with hooks, lures, traps and nets.
4. Northwest Coast Indians, who enjoyed a milder climate and unlimited supply of salmon and other seafood, were fundamental in the development of a unique lifestyle far different from the other groups. They structured their lives according to strict rules, rituals, and regulations of their respective clans. Their artwork was composed of finely woven cedar bark and spruce root baskets and elaborate totem creations.

On both sides of Bering Strait, the southern limit of the greater North Pacific culture area was dominated by cultures with salmon-fishing economies. To the north the coastal economies of Siberia and Alaska were increasingly oriented towards a combination of salmon fishing and sea mammal hunting (Fitzhugh, Crowell 1988, 13).

Another source of the complexity of Alaska's archeological record is the interaction that occurred among the various groups and areas. People did not stay put through time; there was a constant ebb and flow of cultural groups and traits. Still another complicating factor was the continuing contact that existed over the millennia between Alaskan Natives and the Old World of northeast Asia. Ideas, goods, and often people moved back and forth across the Bering Strait. Similarities between peoples of coastal Siberia and coastal Alaska show that the Bering Strait did not prevent contact between their cultures: similar languages, shared spiritual practices, hunting tools, and traditional dwelling sim-

ilarities, distinctive fish cleaning methods, and meat preservation by fermentation (Fitzhugh, Crowell 1988, 18). Today the Siberian Yupik still travel by open boat from St. Lawrence Island to the Chukotka Peninsula.

Heading south along the coasts would seem to be the easiest and most logical direction. In all probability modest-sized groups could cross the Bering Strait and establish temporary camps on the Seward Peninsula within a single season. Once there it was only a matter of time before they found their way to the Gulf of Alaska. What lay before them was the Kodiak Archipelago of which Kodiak Island was the largest. It must have been hard to grasp; ahead was an island rich in varied, abundant food resources, endless bays that gave shelter, a relatively mild climate, and a topography that varied from the open tundra plains at one end to great forests at the other extreme. "Yet in the beginning the island was in all probability just a stepping stone to further journeys eastward and then southward, as long as lands in these directions were free from resistance" (Hrdlička 1932, 2).

Emerging evidence indicates that fully maritime hunter-gatherers were in place on the Kodiak Archipelago by at least 6600 uncal BP (before the present)/ca 7500 ca BP, suggesting an earlier maritime focus on the adjacent mainland coasts of the Gulf of Alaska and/or the Aluetians (Clark 1979). (Recent developments in more precise measurements of C-14 half-life have significantly improved the accuracy of radiocarbon dating. This allows dating in actual years before the present [BP].)

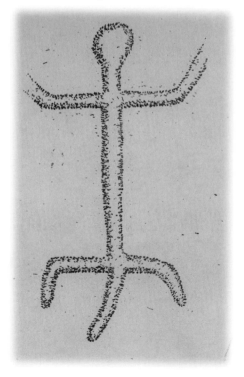

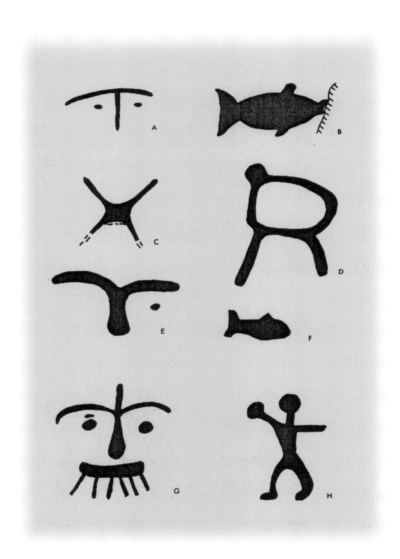

Afognak Island figures

C H A P T E R 4

Qai-cali Kodiak qikertaq?

Why Kodiak Island?

Kodiak Island, fierce in its beauty and alluring in its many moods and faces, is situated in the Gulf of Alaska. Long known for its rich biodiversity and native culture, the rugged coastline and deep fjords of the island and adjacent archipelago have been home to the Alutiiq people and their ancestors for thousands of years—the waters providing abundant resources for these subsistence-dependent people.

Located in the center of the Gulf of Alaska, the Kodiak Archipelago is a grouping of sixteen major islands, plus numerous smaller islands. All are encompassed in a 5,000-square-mile region of a highly biologically productive ecosystem. The three main islands are Kodiak, Afognak, and Shuyak. This island grouping stretches 177 miles from the Barren Islands on the north to Chirikof Island and the Semidi Islands at the southern border. Spanning 67 miles from east to west, there is no point of land greater than 15 miles from the ocean. Thirty miles across Shelikof Strait lies the Alaska Peninsula on the mainland.

> "Man clings to vicinities once adopted by his ancestors and yet the explanation is, I think, simple. The old ones chose the best there was."
> —Aleš Hrdlička 1932

The archipelago has an accumulative coastline of approximately 3,300 miles in length and sits on the Pacific Oceanic Plate of the Aleutian Trench. This slides and shifts against the North American Continental Plate. The entire area is part of a geologic uplift zone, with the landscape's foundation having been sculpted by an extensive combination of volcanic, glacial, and tectonic activity. Some geologists speculate that the archipelago is a continuation of the Mountain Range, which begins on the Kenai Peninsula ninety miles to the northeast (Afognak Geology).

Kodiak Island lies south of the base of the Alaska Peninsula between 56° 40' and 58° north latitude and between 152° and 155° west longitude. The island has numerous mountains with elevations greater than 3,000 feet along its central spine. At 4,470 feet, Koniag Peak, on the southwestern end of the island, is the highest point within the archipelago. The ridge of mountains runs northeast-southwest and is pocked by forty or so small glaciers along the main divide. Rugged headlands, rocky outcroppings, gravel- and boulder-strewn beaches and intertidal flats typify the entire group. Deep and narrow bays with numerous branching arms and inlets are abundant along the 1,000-mile-long coastline.

Lying in the path of the Alaskan Current, Kodiak is the largest, and in many respects the most important, island in Alaska (Hrdlička 1932, 5), due primarily to its unique geographic position and natural resources. These natural attributes are the reason the island was heavily peopled by one of the largest American tribes at the time, the Alutiiq/Suqpiat. This was a main impetus for anthropologists such as Dr. Aleš Hrdlička to spend so much time exploring and excavating the island. During this time anthropologists tried to understand the full range of human diversity, commonality, and where we came from—peopling the Americas. Much of the anthropological data available today on the human past of Alaska and specifically Kodiak emerged from Hrdlička's work. Subsequent works by Heizer, Clark, and Fitzhugh have expanded on, and in some venues queried, his findings.

Specific geographic features within the archipelago include the submerged lands and waters beyond mean lower water. These offshore areas are rich in shellfish, finfish, marine mammals, and marine birds. Shellfish are also abundant on shore in the Littoral Zone. Most near-shore marine waters are diluted by freshwater drainage and are known as estuaries, many of which extend from headland to headland of bays, inlets, and fjords. As a consequence of the fresh water, these estuaries freeze in the winter. Lagoons are most prevalent in the south and southwestern portions of the archipelago and tend to be shallow with sandy or flat shorelines.

Fifty percent of Kodiak and Afognak Island coastlines are exposed bedrock shores. Exposed, high-energy coasts provide habitat for a variety of Littoral Zone (zone between high- and low-water marks) fauna and flora which in turn feed wildlife and fish populations. These high-energy coasts attract and support more than two hundred species of bird populations while also providing food and haulout areas for some twenty species of marine mammals (KICC 2000).

Major lakes and rivers, such as the Karluk, Fraser, Red, Akalura, and South Olga Bay Lakes, are located on Kodiak's southwest lands. Rivers, streams, and lakes provide critical habitat for resident and *anadromous* (fish that migrate from salt to fresh water annually) fish populations. All five species of Pacific salmon are represented. Today approximately 350 streams annually provide significant salmon production for bear food and human harvests. Of these, approximately 3 produce chinook (kings), 33 produce sockeye (reds), 147 produce coho (silvers), 104 produce chums (dogs), and all produce pinks (humpies).

From the uplands to the shoreline, lush vegetation carpets most of the archipelago. Extensive stands of Sitka spruce forest the northern islands, including the northern portion of Kodiak. Sitka spruce on Kodiak Island and the Alaska Peninsula are currently expanding their range southwestward. In 1962 the Territorial Legislature adopted the Sitka spruce as the official state tree.

The bulk of the vegetative features encompass Kodak's Upland habitat, which is clearly marked by elevation. At very high elevations, unconsolidated material is absent. Below the peaks, mountainous areas have typical alpine vegetation. Steep mountains below 3,000 feet have dense shrub and ground cover. Lower slopes and sand and gravel of glacial origin cover valley floors. The southwest of the island, including the land on and adjacent to the petroglyphs, and the Trinity Islands escaped glaciation and are vege-

tatively and topographically different from the rest of the archipelago. The area is characterized by extensive wet and moist tundra surrounded by rounded low hills (KICC 2000). More than 250 varieties of plants have been documented. The remainder of the archipelago has a diversity of habitat types, predominantly shrubs, grasses, and forb complexes (pasture herbs), throughout lowland and mid-slope areas.

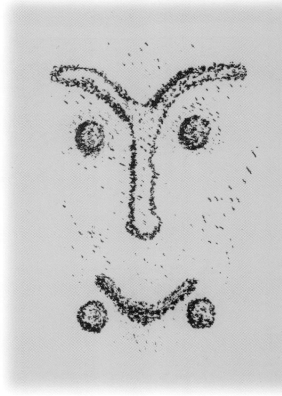

The climate is maritime and subject to quick and drastic changes. However, in general it is considered mild.

Six indigenous mammals inhabit the Kodiak Archipelago. The brown bear *(Ursus arctos middendorffi)*, red fox *(Vulpes vulpes)*, river otter *(Lutra canadensis)*, short-tailed weasel *(Mustela erminea)*, little brown bat *(Myotis lucifugus)*, and tundra vole *(Microtus deconnomus)*. Ground squirrels are also indigenous, though they may have been introduced during the second millenium A.D. by the Alutiiq.

Sitka black-tailed deer and Roosevelt elk were introduced on the archipelago in the 1920s and proliferated. Also introduced and established, but to a lesser degree, were the mountain goat, snowshoe hare, beaver, and red squirrel. Reindeer exist only on the south end of Kodiak. Introduced species that did not survive include moose, dall sheep, marten, mink, and raccoon. Marine mammals such as harbor seals, Steller sea lions, sea otters, porpoises, and whales are common along the coast.

The second largest island, Afognak, lies to the northeast, separated by Whale Passage and Afognak Strait. This 708-square-mile island, like the others, is detailed with bays and fjords. Enormous spruce trees are the dominant forms of vegetation, with commercial logging now playing a significant role in the ecology of the island.

It is here that another known group of petroglyphs in the Kodiak Archipelago has been recorded. In 1970 Dr. Donald Clark presented his findings on these carvings in a University of Alaska anthropological paper. Although unresearched, other petroglyphs exist at Uganik Bay and near Port Lions.

The Afognak Island figures are located at three separate locations. Although isolated, each group of carvings is near a habitation site. At Marka Bay, it has been estimated that approximately thirty figures adorn the seaward-facing surface of a dike. However, during the exploration of them in 1964, most were already in an advanced stage of erosion. In addition to the antiquity of the work, the inherent weakness of the slate-graywacke rock adds to the inability to distinguish the symbolism with any degree of accuracy. Of the two habitation sites nearby, one has been attributed to the late Koniag phase (Clark 1964, 70). The Marka petroglyphs are on Dike Rock and also at Lipsett Point. Those at Afognak Village and one at Luenter are on slate-graywacke.

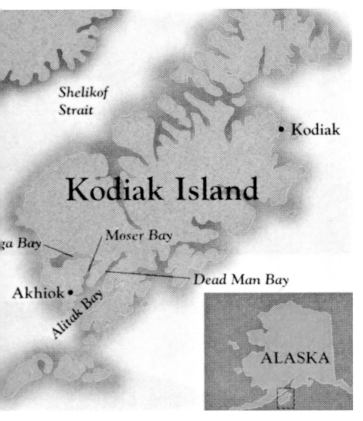

Lipsett Point, towards the mouth of Afognak Bay, has similar representation. All but two of the few petroglyphs that were there have likewise lost their characteristics.

The Afognak petroglyphs are nearly identical to some of those at Cape Alitak and may be related to the rock paintings in Prince William Sound (de Laguna 1956). A feature seen on the Afognak Village group, the diagonal lines extending down and outward from the eyes, is also evident on some of the Cape Alitak images and on a small painted box panel from the Karlink Web site (Alutiiq Museum).

Fifty-four miles northeast of Kodiak City and directly northeast of Afognak lies the smallest of the three main islands, Shuyak Island. Separated from Afognak by Shuyak Strait, the 47,000-acre coastal wilderness is one of six Kodiak Island–area state parks.

There can be no doubt why Kodiak and the archipelago were inhabited. A combination of the climate, topography, and abundance of varied food resources were ideal for a hunter-gatherer society.

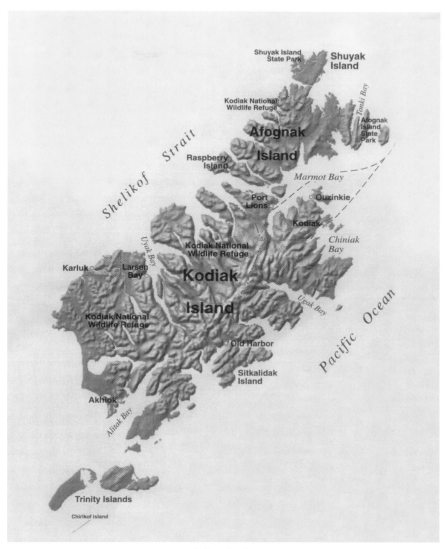

Kodiak Archipelago

There have been several distinct cultural sequences throughout Kodiak's history, three prehistoric periods and one historic period. Dr. Donald Clark and Dr. Ben Fitzhugh have both spent much time and effort in deciphering the complex mix of cultures of the islands. Clark states (1979, 1982) that the oldest accepted period on the Kodiak Archipelago is the Ocean Bay period. The earliest site is found near the village of Old Harbor on adjacent Sitkalidak Island. Dr. Ben Fitzhugh, an anthropologist from the University of Washington, has spent several summers at the Tanginak Springs sites and has unearthed evidence of local habitation dating back at least 7,500 years. Possibly

equally early is the Zaimka Mound located at the entrance to Women's Bay and excavated by the Alutiiq Museum.

The Ocean Bay tradition extends from approximately 5500 to 1500 B.C. That is in the realm of 4,000 years of habitation. Broken up into two periods, Ocean Bay I (7,500 to 4,600 years ago) has as its conspicuous feature flaked stone tools. Ocean Bay II began approximately 4,600 years ago and lasted a few centuries. This era is characterized by a complete change to slate-working characteristics. Pointed implements such as lance points, long spear points, large stemmed and unstemmed double-edged knives, all fabricated from slate, have been found overlying or co-occurring with the flaked technologies. Notched pebbles and cobbles used for line and net weights have also been located in late Ocean Bay I but become common in early Kachemak. Ocean Bay II is physically found overlying Ocean Bay I, which suggests that they are sequential phases of a single culture (Clark). Late in this period, by 2500 B.C., semi-subterranean sod houses had become common.

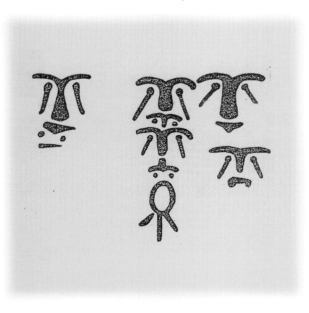

The Afognak petroglyphs

The Kachemak tradition succeeds the Ocean Bay phase and has a time frame of 1500 B.C. to A.D. 1200, lasting in the neighborhood of 2,700 years. Characterized by new tool forms and (late in the period) the development of elaborate ornamentation (labret-wear [body ornaments], decorated stone lamps) and mortuary ritual (Heizer 1956, Workman 1992). This period was notably different from Ocean Bay in the use of mass harvesting and processing techniques (nets and semi-lunar knives) and the establishment of substantial residential sites recognized today as the first villages (Crowell 1986, Erlandson et al 1992, Haggarty et al 1991). Some Ocean Bay sites are of substantial size and can be regarded as villages. Midden deposits show evidence for varied practice with the dead, including cut and drilled human bones, artificial eyes, and probable cannibalism (Clark). The labret, or decorative lip plug, appears for the first time in this tradition. This is a significant observation in trying to establish a time frame for the petroglyphs. Many of the faces carved in stone are adorned with labrets.

The last culture to be described here is the Koniag culture which has been traced to the historical contact horizon of the Yupik-speaking Alutiiq/Suqpiat people. This period pre-dated Russian contact by 600 years. A number of technological and social changes

including the use of composite fish harpoons, gravel tempered pottery, and multiroom houses large enough to enclose extended families (see Jordan and Knecht 1988 or Knecht 1995) occur during this phase. Whale hunting appears to have become a major social and economic activity (Fitzhugh). Villages became larger, defensive sites expanded to serve entire communities, and social inequality showed up in archaeological house size variation (Fitzhugh). Social significance may be attached to Koniag sweatbathing, incised figuring, and petroglyph production. Sites on the southwest half of Kodiak present a complexion differing from that of other Koniag phase sites (Clark). This phase can best be described as an amalgamation of peoples and cultural elements. The changes took place approximately between A.D. 800 and A.D. 1300.

Among the lands occupied by Eskimos, the Pacific area is semi-unique for its rock art, which includes both petroglyphs (Heizer 1947, Clark 1970b) and rock painting (de Laguna 1933).

The Historic period began after A.D. 1763, and once Kodiak was settled in A.D. 1784 by Russian fur traders, it did not take long for them to decimate the sea otter and whale populations. From all accounts this was a hostile and devastating period for the Qikkertarmiut (Kodiak Alutiiq).

In 1867 Alaska was purchased by the United States, with yet another change for the Alutiiq people. The fishing industry was developing and shifting towards the western market economy based on income. Since 1867 there have been several boom-and-bust industries, beginning with whaling, salmon, herring, and crab fisheries.

In 1971 the Alaska Native Claims Settlement Act brought about yet another change, this time in favor of the Alutiiq people. They regained ownership of traditional lands and were forced to form for-profit corporations.

The word *Kodiak* comes from several versions of the name, all referring to the native inhabitants. On August 3, 1784, Gregory Selekhov came to the "Island of Kikhtak," which in the Aleutian dialect means *Kodiak.* In his narrative, Selekhov refers to "the island of Kikhtak which is called Kadiak." Martin Sauer, secretary and translator of Commander Joseph Billing's expedition to the island in 1790, regarded this name as an error. "Shelikoff has called this island Kikhtak, as the original name of it, in which however, he is mistaken, for Kikhtak or Kightak, is merely an island" (Sauer 1802). In subsequent Russian publications it is "Kadik" or "Kadiak" (Davydov and Khvostov), "Kadjak" (Kotzebue), "Kadjack" (Wrangell), "Kadyak" (Coxe), and eventually during American times became "Kodiak." Kodiak was discovered by Stephan Glotov in the boat *Andreas & Natalia* on September 5, 1793.

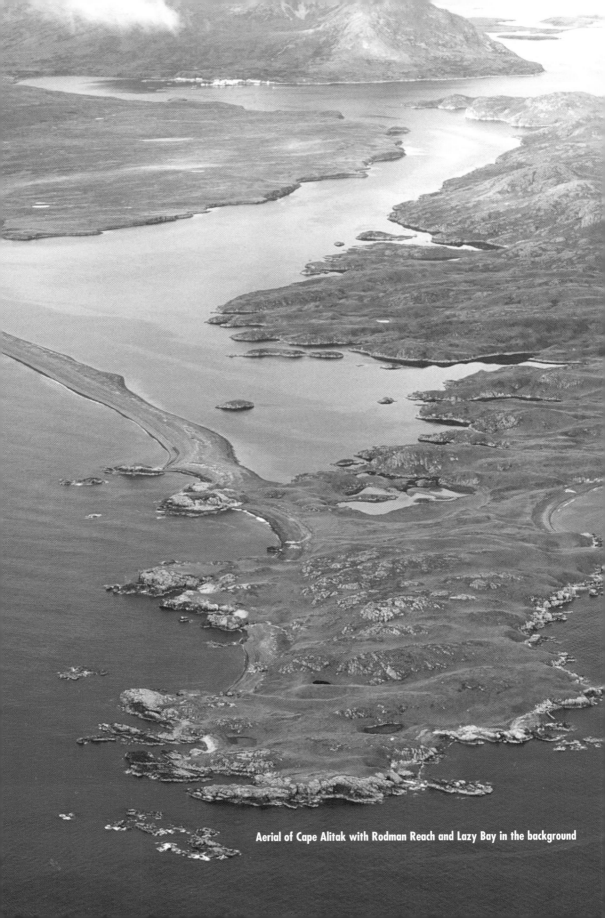

Aerial of Cape Alitak with Rodman Reach and Lazy Bay in the background

Cingiyaq Alitak Patriitaq

The Cape Alitak Petroglyphs

Cape Alitak juts out into Shelikof Strait in the Gulf of Alaska, which is approximately one hundred air miles, as the raven flies, from the present-day settlement of Kodiak City. A fifty-minute flight with Steve Harvey in his 1940s Grumman Wigeon, through the valleys and fjords of Kodiak's mountainous terrain, is a spectacular way to be introduced to the beauty of the south end of the island. Isolated, even by today's standards, these rocky outcroppings are easily discernible as a place of significance. Alitak Bay, rich in biodiversity, attracts hundreds, if not thousands, each year for subsistence and commerce, just as it attracted the ancestors of the Alutiiq people thousands of years ago. The Alitak Bay region is a profusion of animal life, both land and marine.

> "There are numerous and excellently made petroglyphs on Cape Alitak."
> —Aleš Hrdlička 1932, 67

At the cape today there stands a large navigational marker, a sign from the "Young Ones." The red and white structure marks the entrance to the bay and provides visual reference of the fishing district. It also serves as an innate warning to seafarers of the potential wealth that lies within these waters and of the danger associated with the harvesting of nature's bounty. There may have been great technological advances in the equipment used to harvest the resources over the millennia, but the inherent danger is still the same. No one carves symbols in the stone to appease the spirits in this day and age, but many follow similar steps through their own spirituality. The ancient artist observed the natural process, assimilated his spirits and beliefs in his mind, and then transferred that interpretation onto the only medium he knew: that of stone. With today's instant global imagery bombarding us at every turn, a "cerebral carving" may act as a surrogate for modern-day man's "petroglyphs."

Most commercial books on petroglyphs make a cursory mention of Cape Alitak as the northernmost location of rock art in the Pacific Northwest. Accompanied by a simplistic line drawing of a non-outlined face, this is usually all that is theorized. In all fairness to others that reference these symbols without actually visiting the sites, an overwhelming factor is the logistical difficulty of traveling in remote Alaska. These sites clearly fall in that category.

The geographic and physical isolation plays a significant role in the preservation of petroglyphs. Occasional off-road vehicles are brought to the sites, but the busloads of tourists, each vying for a picture of themselves standing beside an ancient mystical image, will not happen very soon. Vandalism that has plagued accessible sites on the "outside"

has stopped to visit here as well. While only little damage was done, through their sheer remoteness and the combined efforts of the Alutiiq community and myself, we feel the best course of action is the use of education to protect "a past civilization's soul of communication." It is with great trepidation that I expose their existence. Knowledge, however, is meaningless if it cannot be shared. One man's insight bears no fruit to the community at large if kept locked in his mind.

Many assumptions are made as bits and pieces of information surface, but the truth be known, no one really knows the individuals who carved these petroglyphs or how long ago. Even their meaning is subject to individual interpretation. However, by studying the history of man and his migrational routes, and by conducting archaeological surveys and excavations, one is able to assemble the myriad of clues and make educated assumptions as to who created these symbols.

Dr. Donald W. Clark makes mention of the petroglyphs at Cape Alitak in a 1975 publication in the National Museum of Man Mercury Series. In 1970 he presented a paper on the "Petroglyphs on Afognak Island." He does reference Heizer's earlier work and makes a comparison between the Cape Alitak and Afognak carvings.

The most recent mention of the Cape Alitak petroglyphs of any significance was over a half-century ago. Dr. Robert Heizer, from the Anthropology Department of the University of California, revisited and expanded on Hrdlička's earlier work. This research was supported by and published in the 1947 proceedings of the American Philosophical Society.

Rounding the cape onboard the U.S. Bureau of Fisheries ship *Blue Wing* on the evening of July 21, 1932, Hrdlička saw Cape Alitak for the first time. As the director of physical anthropology of the United States Museum (Smithsonian), he had been commissioned to undertake a systematic anthropological survey of Kodiak Island. Physical anthropology endeavors to show the human physical and physiological past, and from that show, as far as possible, the right base for future human progress and development. On his second of ten seasons of fieldwork, he arrived on the flood tide at the Pacific American Fisheries salmon cannery in Lazy Bay. He was greeted by longtime friend and owner of the PAF facility, Alfred Foster. The next day they took a small dory up Rodman Reach towards the cape.

The following is Dr. Hrdlička's account of the excursion:

"Visit a blunt point opposite Tanner Head and the Alitak Cape, famed locally for its petroglyphs. Find many of these, also a site on the hill. The glyphs are very well made, deep, cover a number of huge and smaller rocks, some of which are under water at high tide, and are much worthwhile. Photographing difficult—not enough space. Another lot of glyphs on top of the hill. The two sites do not appear of great value, no great accu-

mulations, but both fairly extensive. Another small site with two moderate-sized barabaras on the western side of the hill."

An earlier mention and the first that I can find in print, comes from a 1917 publication in the *American Anthropologist*. Captain C. A. Halvorsen, the superintendent of the Alaska Packer's Association cannery in Olga Bay, took photographs that:

"Show certain symbols cut in the granite formations at Cape Alitak, which forms the northern entrance point of the bay of that name on the southwest side of Kodiak Island. These photographs may be of interest to students of ethnology, and may lead to a better understanding of an ancient people, or possibly of a former race inhabiting these islands."

[Some of these photographs were taken from the end of the cape at an elevation of about 50 feet above sea level, over which the sea washes in heavy weather. The surface of the granite had been worn smooth.]

"The symbols at this point are not very distinct, but they have apparently been cut quite deep in the rock many ages ago. The ledge is badly fissured and many of the original symbols have been destroyed. Those that were more marked were traced with black paint in order that they could be seen in the photograph. There are several hundred of these symbols, but time prevented a complete development of the locality."

As the years pass and knowledge is slowly gained about the petroglyphs, our comments become more sympathetic and respectful towards these images.

Commander Jefferson F. Moser of the U.S. Navy was charged with the duty of exploring and examining the streams and lake systems of Alaska, their general features and characteristics, so far as they related to salmon and other fisheries. While engaged in the salmon investigation, the steamer and crew made a sextant reconnaissance. An excerpt for the ship's log (Steamer *Albatross*) in 1900 conveys his impression upon reaching the south end of Kodiak Island.

"Alitak Bay is a large body of water on the southwestern side of Kadiak Island, about 65 miles by sea from Karluk. The entrance, from Cape Alitak on the west to Cape Trinity on the east, is about eight miles wide and in its length of fourteen miles the bay narrows to five miles at the upper end, where it terminates in two wide arms (Deadman Bay and Portage Bay) each several miles in length. The general direction of the bay is NNE and SSW."

The ship's log continues: "Cape Alitak is the terminal point of an undulating granite ridge, named Tanner Head, about four miles in length, the northern end bordering on Lazy Bay. The ridge is a peninsula, with the highest hills (about 600') at the northern and middle parts, from which there is a gradual roll and descent to the pitch of the cape; this, at the extreme point, is low and rocky. In approaching from the westward it is seen as a long point with rolling hills and knobs gradually shelving to the sea."

Perhaps thousands of years earlier, it was at this terminal point of the undulating granite ridge that the ancestors of the Alutiiq people plied their skills and beliefs, creating in the power-filled stone the symbols still visible today.

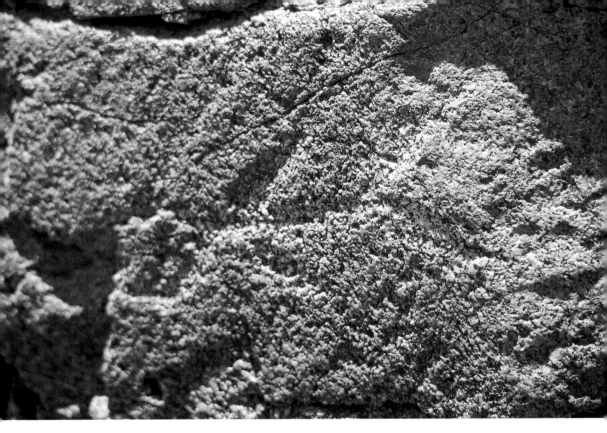

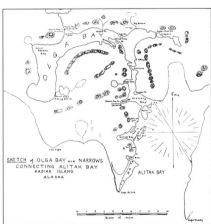

Sketch of Olga Bay and Narrows
connecting Alitak Bay to
Kadiak Island, Alaska 1899

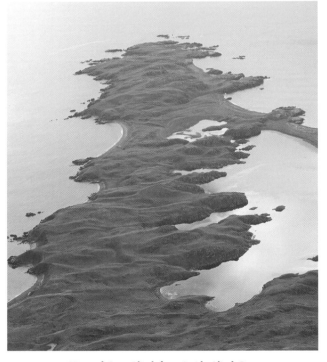

View of Cape Alitak from inside Alitak Bay.
Shelikof Strait in background.

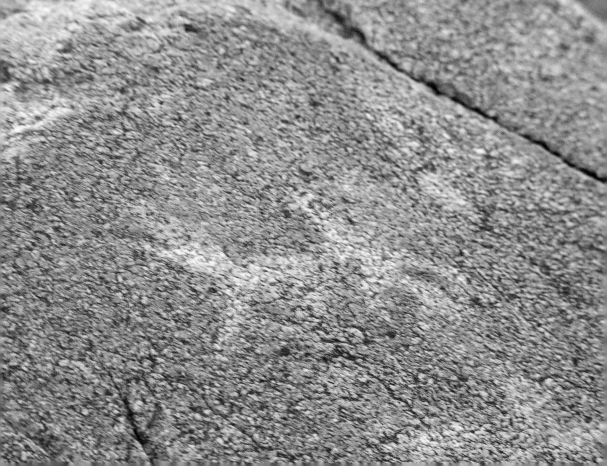

C H A P T E R 6

Kalla'alek

Shamanism

Most of mankind, past and present, has some form of religion or belief system, whether it be Christianity, Hinduism, Unitarianism, Islam, Buddhism, or any one of a myriad of followings. Religion is defined as the service and worship of God or the supernatural. Christians believe that Jesus is the Son of God. By accepting Jesus as the Christ, they will be forgiven for their sins and live with God forever. Hindus, like Buddhists, believe that human souls are born over and over again into different circumstances until they reach perfection or union with God. Unitarians realize the importance of the mind and education. They believe people need to find their own path to God. They also believe in the goodness of the earth and all its inhabitants.

> "We fear the souls of the dead human beings and the animals we have killed. The greatest peril of life lies in the fact that human food consists entirely of souls."
> —Aua, Eskimo shaman

Whatever the form, they all believe in a singular higher being—one that is all-knowing and is always to be revered. The Native, on the other hand, believed all living things and natural objects possessed a spirit (*anerneq*), which has the capability of taking on a variety of physical forms.

In order to sense the meaning or purpose of petroglyphs, one must first look at the animistic frame of mind of the hunter-gatherer societies. *Animism* is defined as:

1. A doctrine that the soul is the vital principle of organic development.
2. Attribution of conscious life to nature or natural objects.
3. Belief in the existence of spirits separable from bodies.

> "The natives call themselves Soo-oo-it, and their magicians Kanghemeut."
> —Sauer 1802, 15

Simply stated, animism's core belief is that all objects and beings (people, animals, plants, the moon and sun, and even the rock) have an intrinsic spiritual quality. All things have their own power and their own spirit. Spiritual questing, a central feature of shamanism in which the individual tries to experience the flux, motion, and change behind the "things" of everyday life, is a constant theme in human history.

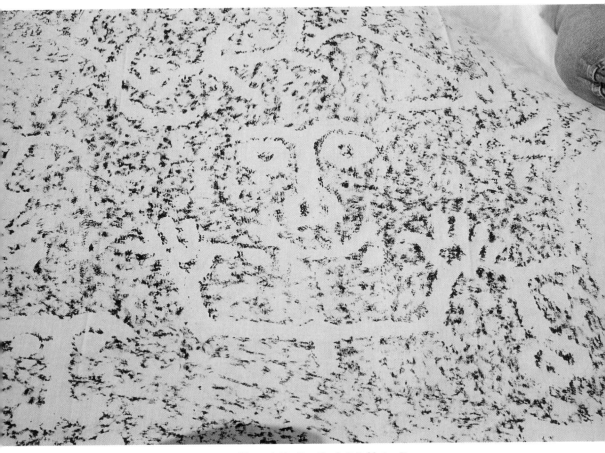

Rubbing of "Smiling Hands," Goldmine Site

The fundamental objective of ritual interaction was connection with the spirits of animals. Animals were not only necessary for survival but were considered as equals, and although they were hunted and utilized, "the killing was not taken lightly; it had the significance of killing another person" (Eliot 1976, 18). Ritual crossed into the spirit world in order to offer atonement for the killing of equal beings and to prevent retribution from the animal spirits. By developing a sacred relationship and honoring the animals' sacrifice, a cycle of death and rebirth became a ritual in the maturing facets of animism. A symbiotic relationship developed between the natural and supernatural, and they eventually became interdependent (Kunkle 1995, 18).

Continuing to evolve, ritual ceremonies manipulated the natural world, in an everlasting round of regeneration and death, leading to the perception that these acts brought forth results. Imitation of a spiritual image, as in the physical carving of a petroglyph, was recognized as capturing the sum and substance of that being.

As humankind advanced, simple rituals, as well as everyday means of survival, inevitably developed into a more refined state, eventually leading to the creation of a position that took control of larger aspects of the tribal environment; thus the position of shaman came to be.

Shamanism is the oldest form of religion known to mankind, having held tribal societies together for at least 20,000 years. If religion is the glue that holds societies together, then animistic shamanism seems to have been successful (Kunkle 1995).

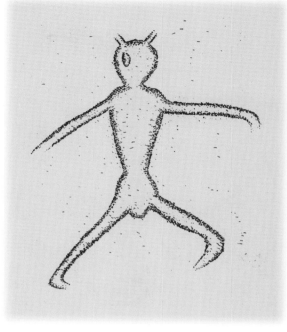

Shamanism, as defined in the *Webster New Collegiate Dictionary*, 1973, is a religion of the Ural-Altaic peoples of northern Asia and Europe characterized by belief in an unseen world of gods, demons, and ancestral spirits responsive only to the shamans. Originating from the Tungus language of eastern Siberia, the term *Shaman*, which means "he who knows," was introduced to southern Alaska during Russian times. The original Alutiiq term is *kala'alek* or one who has *kala'aq*, a helping spirit or supernatural power (Steffian 2001, 208).

The shaman possessed quasi-magical powers and was capable of protecting his followers from the powerful, and often destructive forces believed to permeate the universe. Shamans could change into animals, dive into the earth, or fly through the air. They could cure illness, read minds, foretell the success of hunting, and quell storms. Some used their powers to harm people.

Spiritual transformation was at the heart of the peoples of the Kodiak Archipelago's life and culture, as shown in several of the following carvings. The power of the spirit could bring rebirth, the change of seasons, or abundant supply of game. It sustained life. The shaman was the master of this transformative power, calling upon shamanistic trance and inner journey to gain perspective on the state of his people. Prolonged fasting, sleep deprivation, dancing, chanting, and/or hallucinogenic drugs would enable the change of consciousness to bring about the trance state.

A study of shamanism among the various tribes of our coast reveals many differences in the shaman's role and function. Sometimes he is the sole specialist in the spirit world and sometimes there are also ritualists or magicians whose contact with the spirit world is not as strong and who can manipulate events by the use of magic formulas. Sometimes these formulas are inherited and the original spiritual experience may have belonged to a

mythical ancestor. Some shamans can cure, some cannot, but irrespective of cultural variations the shaman is an individual publicly acknowledged as having a high degree of power from spirit beings; the shaman acts as a public intermediary between ordinary men and the spirit world (Hill 1975, 41).

Shamanistic practice has gradually been exorcised in modern times, and has been relegated to the realms of the exotic and mystical. Shamanistic practices have been categorized by scholars as "magical," "animistic," and "supernatural"; by missionaries and colonial administrators as "paganistic," "satanic," "idolatrous," and "superstitious." All of these categorizing words deny the everyday reality of this form of human activity. Regardless, shamanism has left its legacy in medicine, mythology, culture, and religion. In addition to its social legacy, shamanism has, over many centuries, left us physical remnants, the most visible of which are petroglyphs. Because these figures and symbols are pecked into stone, they have survived to taunt our imaginations and mutely attest to the ritual past (Jacqueman 1995, 21).

Interpreting the meaning of petroglyphs is somewhat speculative, as they were used by a succession of peoples over long periods of time. They can, however, be grouped according to function into four categories: graffiti, recorders, markers, and ritual.

Graffiti—It is unlikely that more than a very small percentage of petroglyphs were made aimlessly with little function in mind.

Recorders—The mundane course of human events is always punctuated with events that merit special notice. Such events were recorded because they represented occurrences of spiritual power.

Markers—Markers are figures or symbols that convey a meaning much the way "traffic" signs do. The symbols might have a deeper or secondary meaning, but its primary purpose was to convey a particular idea.

Ritual—The most prevalent type of petroglyphs is that used in the various permutations of ritual. The vast majority are products of ritual ceremony intended to utilize the powers of sympathetic magic (Grant 1981, 24; Schaafsma 1980, 24).

It is equally difficult for us to understand the function of the petroglyphs in terms of the people who made them. "What is so difficult for us to grasp is the inseparable interlocking of matter with its spiritual content" (Gideon 1975, 284). We must try to understand that the Native sees himself as a humble element embedded in the world around him.

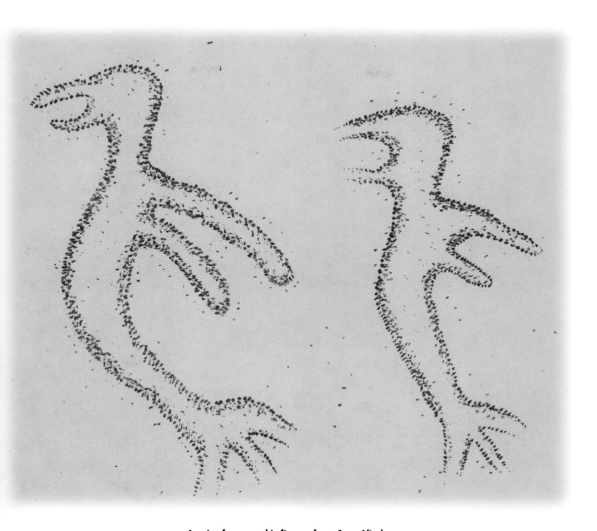

A pair of zoomorphic figures from Cape Alitak

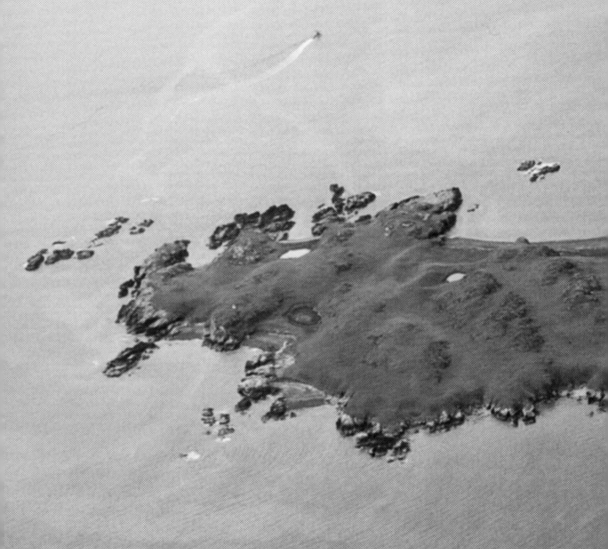

View from inside Alitak Bay at Cape Alitak

C H A P T E R 7

Qiug cingiyaq enwia

North Cape Site

Agreat mysticism pervades this area—not something a trained anthropologist would confess to, but something I can put forth. A particular force radiates from here, for those that believe an open mind and open heart are vulnerable to channeling these energies.

I chose to separate the Cape Alitak petroglyphs into two sites. Firstly, because of the physical geography, and secondly, for the subtle change in symbolism (difference in spirituality that I felt). The sites are separated by a boulder-strewn beach and small channel that during most stages of the tide, has a great surge washing through it. Although you can walk between sites in a few minutes, I feel they are distinctly different in their message.

The North Cape site sits atop a large granite outcropping that faces west-northwest (WNW) towards Shelikof Strait and the Trinity Islands. The distinctive reddish wash of the rock can be seen for many miles. When the setting sun drapes its glory over the surface, a surreal moment is created. A glow emanates from the rock, like the fading embers of a campfire. The surface has been worn smooth; no doubt from the seas washing over it in heavy weather, the elements, and time. Upon closer inspection you can see that the area is greatly fissured.

While not volcanic itself, Kodiak Island is so near the great zone of volcanic activity on the Peninsula that earthquakes are common, though generally of small intensity. In 1792, however, according to Davydov (2: 156):

"There was experienced on Kodiak a heavy earthquake which lasted 18 hours. From it all dwellings were thrown down, and a number of rocky formations were broken."

The area is approximately 130 feet wide at the inland base, 47 feet in depth at the southern perimeter, and 91 feet to the ridge on the northern edge. The average elevation is 50 or more feet above sea level. The inclination of the site ranges from 10° to 30° but most carvings had been created on a 20° to 21° incline. The slope of this site is not towards the water as in most instances, but towards the land.

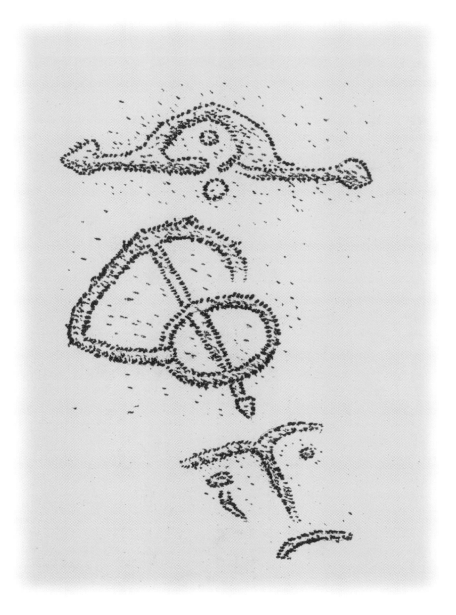

Cluster of carvings at Cape Alitak

The seaward face of the site is sloped from 30° to 85° making it difficult to explore. After taking all the angles and levels into account, I calculated that the heart of the site encompasses approximately 12,000 square feet (approximately 1/4 acre). In his 1947 synopsis of the cape, Heizer estimates "the first locality covers an area of

about three acres." He has undoubtedly combined the two sites at the cape into one and has included the total locale. His method of encompassing the entire area is, in general, reasonable as my measurements pertain to the immediate canvas.

The symbols in part are worn beyond recognition. On the other hand, some are evidently manifest. Regrettably, the worn ones have a majority. The spatial orientation includes random single symbols and groups of seemingly unrelated symbols throughout the area. There are also specific panels with several images that portray a story. The images on the following pages have been accumulated after many years of visits and endless hours of collecting data. Inherent in this process, there have been numerous skiff rides and many miles logged walking the beaches to and from the petroglyphs in all manner of weather. Those of you familiar with Kodiak weather can appreciate my note. Also, scouting the surrounding headlands and beach rocks for any solitary carvings, only one, well-weathered face was found by itself on a small boulder between the Goldmine and Bear Point sites. All these actions were integral to the task at hand of collecting information.

The practical labor involved in singling out an image and recording its physical parameters—height, width, average depth, inclination, orientation to the water, quality, and direction of exposure—and whether the image was easily discernible, vaguely visible, had to be rubbed, or came to life when the long slanting rays of the setting sun brought it back from the spirit world for just a few moments. The following interpretations come from a combination of exhaustive academic research, discussions with indigenous peoples, humanities scholars, countless hours spent analyzing hundreds of photographs, and in great part, from my individual impressions and approach. I was very prudent not to impose my views or fill in the lines, so to speak.

Cimirluni

Transformation

TRANSFORMATION is defined as the operation of changing one configuration or expression into another. Located at the North Cape site, this carving (next page) is part of a rock panel that incorporates a sequence of whales. Orientated towards the west, this 22.5° inclined section of granite depicts an assembly of great whales heading through Shelikof Strait.

I feel that this image is of an anthropomorphic figure beginning the process of changing from one configuration into another. The elongated neck could be that of a shaman allowing his spirit to leave its earthly form and transcend that of the whales. The arms begin to resemble the pectoral fins and the feet appear to be turning into the tail flukes. The head and neck stretch into the enormous head of the whale. In some species of whales, the head comprises up to 40 percent of their mass. A bit of proportional

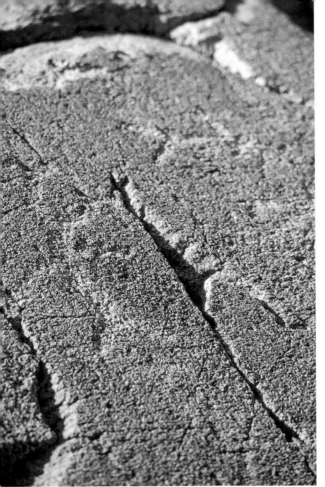

Transformation figure at Cape Alitak

math shows that the head and neck comprise approximately 35 to 40 percent of this carving.

The halo of radiating lines coming from the head could be the early stages of plates of baleen. Baleen is used by the non-toothed whales to strain krill (a small shrimp-like crustacean) and bait-fish from the surrounding water. More likely, these lines, which have been identified frequently in Siberia, are believed to be associated with sun deities and with shamans whose reputed power to journey to the sky as well as to the underworld links them to the heavenly bodies.

Measuring 20 cm in length this symbol (left) may appear small at first glance. The significance comes from its position at the head of the panel and by comparing its size in relation to the whales on the same granite face. Taking these factors into account gives one the rationale to envision a significant power manifesting. He may also be using the smaller whale next to him as a messenger to intercept the path of the larger group, to call upon the whales to give themselves freely to the food supply.

This petroglyph (right) is one of many that illustrate some form of transformation. The idea of animals being transformed into men might of course be interpreted as a bizarre parallel of evolutionary teachings, but as stated previously, in all non-human forms, ordinary animals were considered to have souls and by showing respect to all creatures, the shaman hoped to entice the great whales close enough to shore where a whaler (*arwarsulek*) could cast a poisoned spear.

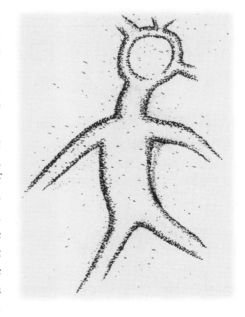

Arwaq

Whales

"Outstanding food of the Koniags is whale meat,
and especially whale blubber and other fat,
without which they almost could not live and would be dissatisfied
even if having abundance of fish and meat . . ."
—Davydov (2:1)

Dependency on marine mammals such as seals, sea lions, and whales was paramount in the subsistence lifestyle of the Alutiiq people and their ancestors. Whales are found in all the world's oceans and even a few rivers. There are at least seventy-five species of whale, each with its own unique characteristics. However, whales can be classified into two groups according to their feeding technique: one having teeth and other having baleen plates.

The scientific order Cetacea includes all whales. The word *cetacean* is derived from the Greek word *ketos* and the Latin *cetus*, both meaning "whale." This large order is further divided into three suborders: the Odontoceti or toothed whales which includes killer whales, dolphins, porpoises, beluga whales, and sperm whales; the Mysticeti or baleen whales which includes blue whales, humpback whales, gray whales, and right whales; and the Archaeoceti which are all now extinct.

The term "baleen whale" is another name for the suborder Mysticeti. The word *Mysticeti* is derived from the Greek word *mystax* for "moustache." Instead of having teeth, the baleen whales have mouths lined with giant, flexible combs of material called *baleen*, or whalebone, which is used to filter small fish and crustaceans from the water.

Monkshood, a powerful toxin used to coat spear points

Baleen whales have two external blowholes and are larger in size than most toothed

whales. Sometimes they are referred to as the "great whales." This classification is further divided into the roquals, the gray whales, and the right whales. All three groups are slow-swimming plankton feeders that stay in relatively shallow waters

The Alutiiq hunter sitting in his bidarka on the rolling waters of Alitak Bay didn't have this information available to him and would probably have regarded it as irrelevant. He already knew these were great creatures and that the spirits he had portrayed in the carvings of the rock had brought these gigantic animals within his reach. The migratory path of the Pacific Ocean's great baleen whales sets a course that heads directly into the Gulf of Alaska and through the rich waters surrounding Kodiak Island. Even to this day, the blue, fin, sei, humpback, gray, and right whales make their way from feeding grounds in the Bering Sea that passes directly by Alitak Bay.

There is evidence that these early people were familiar with Odontoceti, the toothed whales. At the Goldmine sites there is one carving of a killer whale and one which appears to be a sperm whale, but it is the slower moving Mysticeti whales that are depicted more frequently at the Cape sites.

The waters of the Gulf of Alaska are exceedingly fertile due in part to winter turbulence and density inversions, which bring bottom nutrients into the upper water column (Ackerman 1988, 220). During the spring this water column becomes more stable and with the increased daylight, photosynthesis (the formation of carbohydrates in the chlorophyll-containing tissues of plants exposed to light) takes place with phytoplankton and zooplankton (microscopic life), and invertebrate populations develop exponentially. This is an essential part of the diet of baleen whales. Alitak Bay and surrounding waters of the Kodiak Archipelago are a virtual soup bowl. These migratory mammals spend their summer straining this rich diet throughout their baleen to build up their fat reserves.

A significant aspect within the subsistence and economic system of these early people was poison-dart-whaling. Initiated from a one- or two-man bidarka, whales were struck with a poisoned dart and left to die. After striking his prey, an Aleut whaler would withdraw to a special hut for three days, where he fasted and mimicked the sounds of the dying animal in order to hasten its death and prevent its escape (Veniamenov 1846, 224). Several days would pass before the hunter would find his prey adrift or washed up on shore. The method of poison-dart-whaling was a prehistoric antiquity on Kodiak Island. It was possibly as old, or older than, the Ocean Bay II phase (Black 1968, 220).

Organized as a secretive cult, the whalers were elite specialists with high status in the community. They differed from other whaling groups up and down the coast in their spiritual concepts. Among the Koniag, whaling magic was hidden, dangerous, and polluting. Its aim was to control and conquer whales, whereas for example, the Inupiat goal was to attract whales through their attention to cleanliness and spiritual harmony. They were considered more like spirits than humans for their ability to land enormous sea mammals. In Alutiiq, whalers were called *anwarculi*, "shamans who hunt whales."

They would wear bentwood hunting hats to transform themselves into predatory killer whales (Black 1969).

Hunting was done from kayaks by men armed with large slate darts dipped in a potent nerve poison. Once the whales had moved in from the open sea to the bays to feed, a hunter could covertly approach a smaller or immature (typically) animal and cast a poisoned dart, using a blade of ground slate propelled by a wooden throwing board. Each dart was inscribed with the hunter's marks so that ownership could be qualified. The strike was aimed at one of the flippers or, as a second choice, the tail (Langdirft 1988, 223). From his analysis of the pharmacology of aconitum, Bisset concludes that the small quantity of poison that could have been carried on the head of a whaling dart would have been insufficient to kill a whale outright. It could have caused paralysis of one flipper, however, so that the whale would have been unable to keep upright and would have eventually drowned.

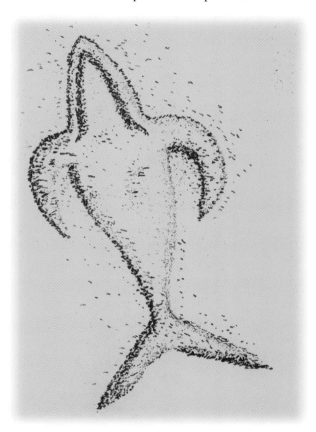

A perennial flowering herb of the Aconitum genus, *Aconitum delphinifolium,* known as *monkshood* or *wolfsbane,* was used to coat the darts. This plant contains the powerful toxin aconitum that can paralyze the nervous system and dangerously lower body temperature and blood pressure. Native to the Northern Hemisphere, most species bear blue or purple flowers that resemble the hood of a monk. Wolfsbane derives from an old superstition that the plant repelled werewolves. According to legend, wolfsbane was created by Hecate, patron goddess of witchcraft and benefactor of the sorceress

Great Whale at Cape Alitak

Medea. In various times and places over the centuries, the herb has been used to kill wolves and tigers, execute criminals, and poison wells against an advancing enemy. It has been used medicinally in a liniment tincture, and as a coating for spears and arrows for hunting. The drug aconite, containing the active principle alkaloid aconitine, is used as a sedative.

"They also used poison on their arrows, and aconite is the drug adopted for this purpose. Selecting the roots of such plants as grow alone, these roots are dried and pounded, or grated; water is then poured upon them, and they are kept in a warm place till fermented; when in this state, the men anoint the points of the arrows, or lances, which make the wound that may be inflicted mortal" (Sauer 1944, 177–8).

Various methods to discipline the actions of the whale, both before and after striking it with a dart, were tried. An intestinal pouch filled with "fat drawn from a dead male child" would be dragged by a shaman in a kayak across the mouth of the bay behind entering whales, confining them to the bay where they could be attacked (Hrdlička, 1944, 126). A "poison" made of human fat was similarly used to prevent wounded whales from escaping into open waters.

Each whaler maintained a secret cave where he stored hunting gear and prepared for the chase. Here he acted out hunts with model kayaks and prepared deadly hunting poisons. The whalers would store and preserve the corpses of their excellent men in remote holes and caves, where they gathered just before the start of the hunt. They carried the corpses to the nearby brook and laid them in the water, which they afterwards drank. When a whaler died, his corpse was cut into pieces and each would take a piece for the purpose of smearing his arrowpoint or spearpoint

Dead whales were given a drink of fresh water and then butchered on the beach. People smeared themselves with fat and blood to honor the animal and show their gratitude for its sacrifice. This insured future whaling success (Alutiiq Museum 2001, 1).

Although challenging to harvest, they were an important subsistence resource. Even a small animal could feed a community for several weeks. Whales also provided bone for tools, baleen for baskets, sinew for thread and cordage, and flexible membranes for clothing.

Arwaq aprun

Whale Passage

On the same inclined panel of granite as the transformation symbol, and directly related, is a series of whales. I believe that each of the groupings of symbols found throughout the sites signifies a story, perhaps a shaman's interpretation of a dream or an event that took place. We know these people were hunters of marine mammals as evidenced by unearthed remnants of bones.

Both the North and South Cape sites have whale carvings. I can verify that the North Cape site has eleven cetaceans and the South Cape site has three and possibly four.

It is this grouping of whales that speaks silent volumes. True to life these creatures are depicted in a social gathering. The symmetry of the body is in realistic form, no small feat considering a hand-held stone was used to chip away the hard granite.

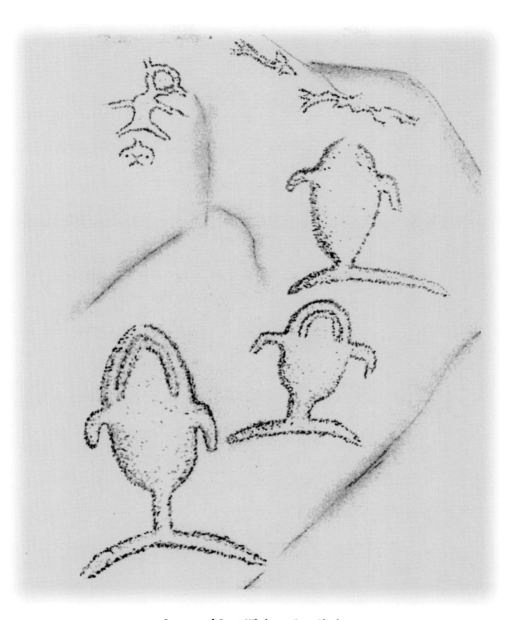

Sequence of Great Whales at Cape Alitak

59

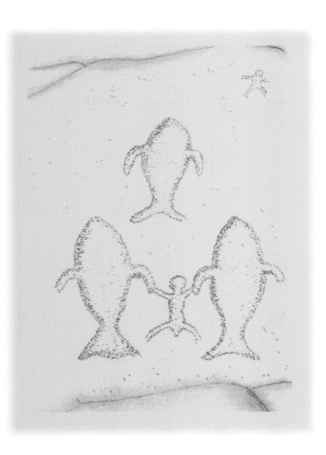

Nukallpiaq arwaq qamani katurlluteng

Man & Whales in Harmony

This panel was difficult to see and reproduce. It took many photographs at varying angles and light conditions, and several rubbings to expose what was there. Needless to say, the effort was but a miniscule sacrifice once the outcome came to focus. The figure at the upper right is the transformational entity on the previous pages. One could translate his posture as beckoning the group of whales to join him in giving themselves freely to the food source. It appears that his spirit has already preceded him to help guide the whales. Significant is the joining of hands and pectoral fins. This sequence of carvings shows the interconnection between animal and man, and between harmony and survival. The Native believed that he was merely a humble element in the world around him.

Kalla'alek taangkaaq qupuraq

Shaman with Drum & Stick

The association of the shaman with his drum is circumpolar. Perhaps the regular hypnotic sound of drumming on the rocks with another rock brought the shaman into a state of ecstasy.

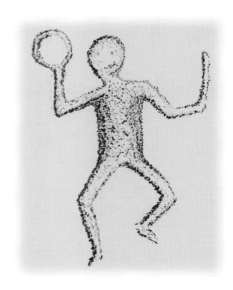

Lliilerluni Aigaq agyaq

Drummer with Star Hand

This carving is located at the North Cape site. Unusual from other anthropomorphic figures is that the drum is in the left hand and the hand is star shaped. I have come across this only one other time. After close scrutiny, it is evident that the star is a natural geologic occurrence and that the carver incorporated nature's gift.

It was thought that a naturally occurring feature of the stone held more power, more magic, than one that was created by man (Smota 1989).

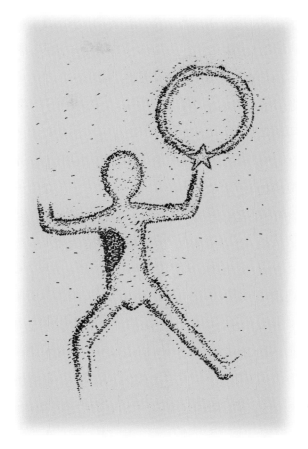

Curving Woman

This petroglyph is the only one that I have discovered that is indicative of a woman.

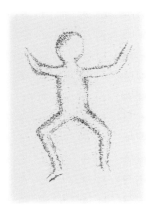

Dancing Man

Dancing was a big part of ceremony. Raised arms represent the healing power of dance.

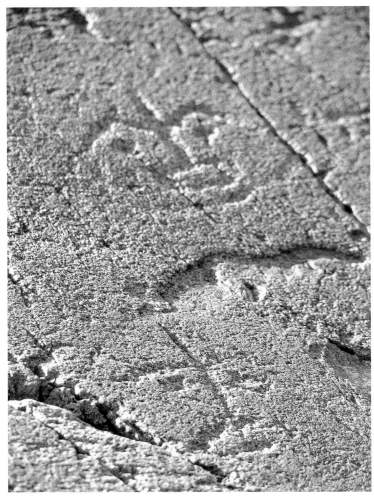

Two mask carvings looking out from the spirit world to this world

Maaskaaq

Masks

> ". . . the rock is merely a 'veil' between this world and the spirit world,
> and rock art is the destruction of the veil."
> —Dr. Lewis-Williams 1987

The North Cape site has several mask symbols. Although extremely faded, they come out for a few moments under the right light conditions, typically when the long shadows are cast by the setting sun, which is rather poetic, adding to the mystique by coming to life, so to speak, as the light fades to night.

Masks were part of the dangerous process of communicating with the spirit world. They were used in dances, the primary venue in which the masks were worn to propitiate the spirits controlling the universe and bring success in hunting.

By showing reverence to animal spirits and ancestors, they believed the masks to have a transformational power that facilitated communication to the spirit world.

Masks were not only used to tell a story, but contained a certain "power" when worn. The person wearing the mask felt the "spirit" of the creatures carved on the mask enter into them and became part of them. The masks provide insight into animistic religion and cosmology.

A mask is not primarily what it represents, but what it transforms. It transforms the wearer by first denying who and what the wearer is, then it defines who and how powerful the wearer has become.

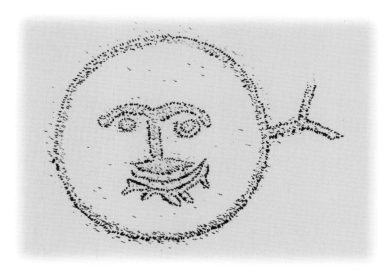

In many cultures, the shaman in his trance passes through the rock into the spirit world, and to communicate what has happened in the trance, the shaman depicts what had happened on the other side of the rock. More than once I have been witness to the sudden appearance of a face from the rock surface. The masks are clearly intended to give the effect of looking out.

Following ceremonies, masks were broken and discarded. This tradition reflects the spiritual power of the images they portrayed.

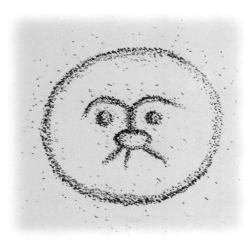

Isuwiq maaskaaq—tangrulluku

Seal Mask—Looking at You

The locals call this image "Looking at You" because it looks like the face of a seal staring back.

Maaskaaq

Mask

This mask has the appearance of a pumpkin, mainly due to the stem coming out of the head. I feel that this is all that remains of some type of headdress.

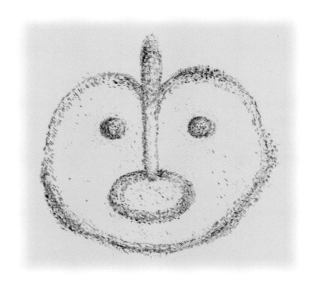

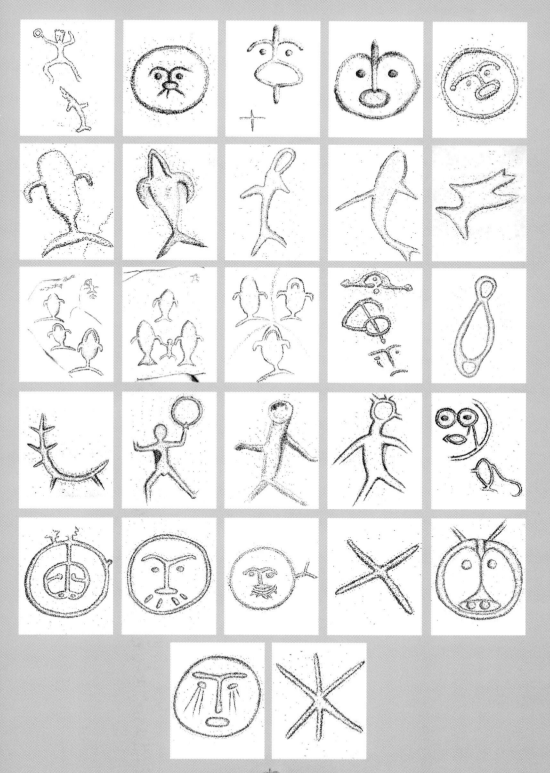

CHAPTER 8

Kia cinquiyag enwia

South Cape Site

Separated by a small chasm and a boulder-strewn beach, the South Cape site is, in some ways, like a miniature version of the upper North Cape site. Yet it is unique in other ways. Nestled in a cove 300 feet to the south, the rock formation blends into the surrounding beachscape, protected from the full force of the sea by a sloping headland that approaches half the height as the North Cape.

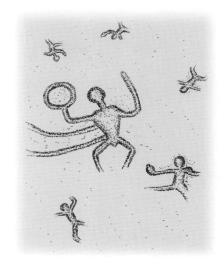

The main area or rock canvas is approximately 30 feet in depth by 70 feet in length. The rock slopes on all sides with the top being somewhat level. The average elevation is perhaps 20 feet.

The sentiment I get from this place is one of less ceremony, but of greater physical energies being expended here. That would seem a mistaken view since there are several carvings of dancers, some holding a ring together and others holding some form of rattle or small drum. There are more carvings here than at the larger North Cape site, but confined to a much more restricted area. Also the size of the symbols seems to be proportionately smaller in relation to overall size difference between the two sites.

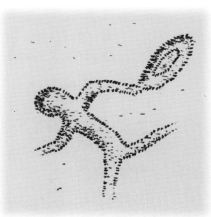

Each location has one carving or panel of carvings that stands out. This site has one of the most exceptional examples centered on an altar-sized boulder at the summit of this rock. The boulder is somewhat triangular in shape and measures approximately 4.5 feet across the westerly edge, 4.25 feet across the northern lines, and just shy of 3 feet across the top. It depicts a shaman with drum in his right hand and stick in his left. His overall dimensions are 7.5 inches in height and 8 inches in width. His triangular torso at the chest is 2.75 inches. He is surrounded by dancers such as the above example. That in itself is a marvel, but to even make it more mystical, this whole panorama is superimposed over some type of mask.

The lines of the drum intersect an eye on the mask and the curve of the drumstick joins the curvature of the head, but regardless of the light conditions or the multiple

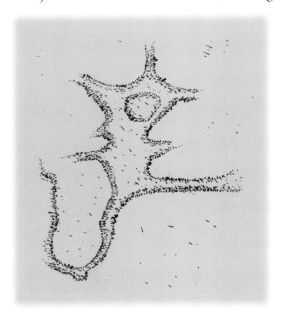

rubbings done or the numerous photographs taken, it is so faint that I can only speculate as to its exact nature. The "Old Ones" are not willing to give all their secrets away . . . not yet.

The work is relatively intricate, which is monumental in itself considering the stone tools used.

This site has a wide array of carving types. There are many stylized faces and anthropomorphic images, from simple line designs to elaborate dancers to a figure with a star head. Several zoomorphic figures include a whale feeding, a sea lion with radiating lines coming from its head, and many incised patterns that have been perplexing to understand and attribute a meaning or purpose to.

A young local man looked at these nonsensible images and matter-of-factly said, "These are maps of where they lived or had fish camps. Some are maps of where they hunted." Put in that context, the realm of possibility was plausible.

Qapuk —arwaq neregkwarluku

Bubbling—Whale Feeding

This symbol depicts a whale blowing bubbles. Located at the South Cape site, this carving indicates that these ancient artists were familiar with the feeding habits of the great whales. Alaskan Natives have long been known for their affinity with the land and its resources. Their survival in this world and the next depended on their ability to make the most of what the land offered.

There are two similar carvings at this site. Both comparable in style and size, sig-

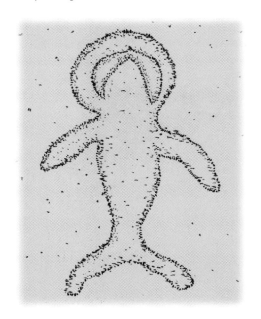

nifying a common artist. The one depicted here is still clearly visible to the naked eye, while the other situated closer to the surf is vaguely identifiable under the right light conditions. In fact, in all my visits to this site, I have only been able to locate it once.

One of the most dramatic whales that visits Kodiak waters is the humpback, whose name, *megaptera novaeangliae*, is derived from the Greek *megas* for "large" and *petron* for "wing" or "fin" and from the Latin *novus* for "new" and the Middle English *angliae* for "England." There is no large whale species more animated or acrobatic than the hump-

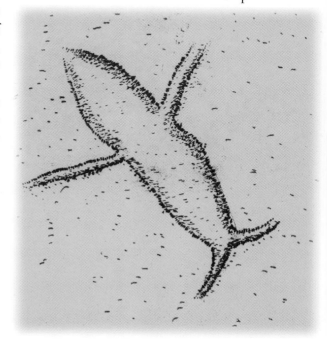

back. It is known for its spectacular leaps and long, white-sided flippers. A member of the Balaenidae family, Mysticeti, the baleen apparatus is at its most extravagant in this species with 270 to 400 plates on each side. The head is huge, in some up to 40 percent of the body length. All seven neck vertebrae are fixed into a single unit to support the enormous weight.

Humpback whales feed on krill and schooling fish. One interesting feeding behavior has been described in which the animals circle a school of fish or krill from below, emitting a bubble curtain as they ascend slowly to the surface. Once the fish or plankton are confined within the "bubble net," the whales charge through it, their mouths open, engulfing the prey. If the krill or fish are centered near the surface of the water, they use a method called lunge feed-

ing. At high speed the whales lunge up from below breaking the surface with vast mouth agape, taking in a huge gulp of krill and water, and filtering out the food with their baleen.

The long summer days provide Alitak Bay with plenty of hours of daylight for photosynthesis, which is why Alaskan waters are so green. Small schooling fish and krill depend on this plant life as their food source. An adult humpback whale can grow to be up to fifty feet long and can eat over 2,000 pounds of krill in a single day. It must have been magical for a lone hunter in his bidarka out in the waters of Alitak Bay to have one of these behemoths lunge up beside him. It could only reinforce his belief in the spirits in the stone.

This is another example of a humpback whale, also located at the South Cape site. It is much more simplistic, but characteristic of the long front flippers that are nearly one-third of the body length.

Shaman encircled by dancers at Cape Alitak

Right: Dancers joining hands at Cape Alitak

Lliilerluni

Dancers

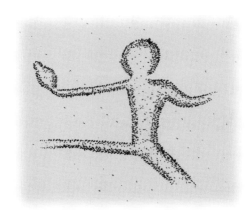

Right: Located at the South Cape, this dancer is one of five that surround a shaman holding a drum in his right hand and a stick in his left. In the right hand of this figure there appears to be a rattle.

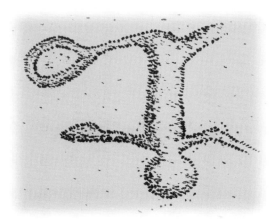

Left: This dancer is one of the five also and has a similar shape in his hand, unusual not only by the fact he or she is portrayed upside down, but attached to the foot is a large rattle or drum.

Sea Lion

Right: Standing only 5 inches tall and placed low on the rock, this image first struck me as a sea lion—another example of a transformation occurring. The rays emerging from the head are indicative of Shamanistic intervention. Marine mammals were a large part of the subsistence lifestyle of the people living on the coast.

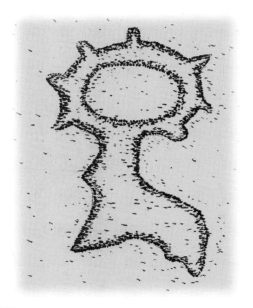

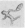

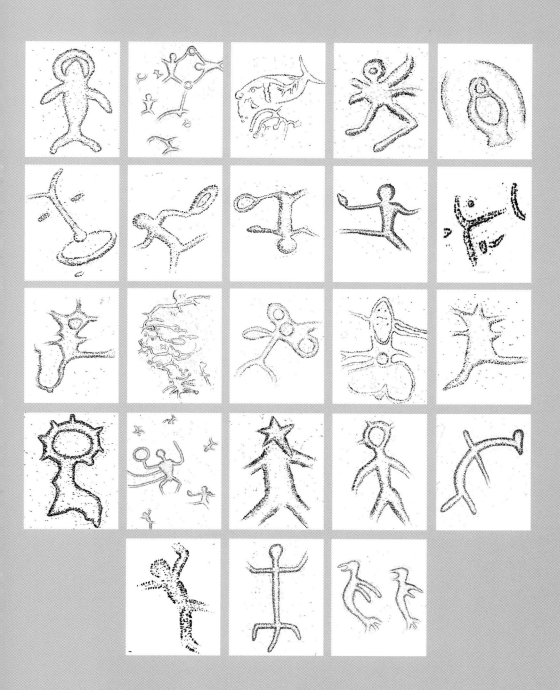

Ledge of faces, Goldmine Site

CHAPTER 9

Suulutaaq enwia

The Goldmine Site

The setting for the third and fourth petroglyph locations, locally known as the Goldmine Site, are located approximately one-half mile east of the Cape glyphs. The easiest way to get there is to follow the age-worn bear trails along the southern cliffs of the peninsula. A twenty-minute hike through these deep-rooted, narrow tracks, gives one a new perspective of just how isolated these symbols are.

I use the Goldmine heading for these carvings mostly as a colloquial phrase. In the early 1900s, several claims were staked on the gold-bearing dune sands of Alitak Point. Records indicate that only a small amount of gold was recovered. The Alaska Westward Mining Company purchased a group of these claims in 1935 and by July of that year a mill was in the process of being built. The rationale behind this project was to treat wind-blown dune sands for their gold content. The sands also contain a large amount of magnetite, which is a natural magnet and a main component of iron oxide (Fe_3O_4). The bedrock of Tanner Head, of which Cape Alitak is the tip, is composed of quartz diorite. When molten rock (magma) is under high temperatures in the Earth's interior and is ejected onto the surface during volcanic eruptions, it eventually cools and solidifies becoming mineral crystals. As these crystals form, they join together or interlock into masses of igneous rocks.

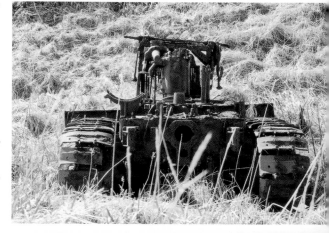

Rodman Reach separates the quartz from the Mesozoic slates and graywackes to the northwest.

Today, encroaching sand dunes threaten to engulf the mine's last visible reminder of a once active site. Through the mounds of sand and tufts of beach grass (*Elymus arenarius*), you can still see the boarded-up entrance, guarded by the relics of a donkey engine. A 65-horsepower gas engine, which powered the mill, included a bin from which an endless bucket conveyor was to carry the sand to a hopper. This in turn was to feed a centrifugal bowl separator, with the waste to be discharged onto the beach through a flume. Donkey engines were a slang term used for the engines and winch systems used.

Around the corner a Best-brand caterpillar sits idle, slowly flaking off layers of rust—its once solid steel spokes now divulging the amalgam of metals created to exploit the inherent strengths of each element. The space created by the down stroke of the engine's cylinder is now filled with the nest of a Yellow Crowned Sparrow (*Zonotrichia atricapilla*)—an early form of recycling, and a practical joint venture between man and nature—a far cry from the days when the four-cylinder tractor, equipped with a scraper, rolled over the beach moving the sand to the ore bin. It must have already been an old loader when brought to its final resting place. In 1925 the Best and Holt Tractor Companies merged to form one of the world's dominant earth-moving equipment conglomerates, the Caterpillar Company. Although slowly returning to the earth, it still stands sentinel as a symbol of modern-day man's belief system.

There are two sites. The northern site is backed by a rocky cliff face and high tundra bank, portions of which are covered during high water. The southern site sits on a small promontory, is partially covered by the tide, and holds some of the most distinguishable carvings. At first notice, these glyphs look like they have been outlined in chalk. Upon closer examination, I thought there were small barnacles growing in the lines. After closer scrutiny, I realize that the underlying crystals of the granite rock are showing through. The black surface is a patina (rock varnish) formed naturally over the rocks through time. These granite rocks have a northwest exposure and are for the most part a dark black in color. The glyphs all face Alitak Bay. A small cobblestone beach separates the two sites.

Characterized by a few anthropomorphic and geometric figures and a few zoomorphic representations, but mainly by stylized faces (Clark 1970), there is a sense of power and intrigue surrounding this site (Appendix II & III). At the onset of this project I had a premonition and had hoped to significantly experience some of the mystique surrounding these historical treasures. This place certainly fulfilled that curiosity.

There is a conundrum of activities and energies surrounding this location. Unlike the more ceremonial and ritualistic atmosphere found at the Cape, the Goldmine locale emanates the struggle of day-to-day subsistence. The adjoining beach is gently sloping, mildly curving, and easily accessible. An ideal beach, where one could haul out a marine mammal such as a whale and butcher it.

The remnants of numerous *barabara* (Russian: A semisubterranean house constructed of wood and covered with an insulating layer of sod; known in Alutiiq as a

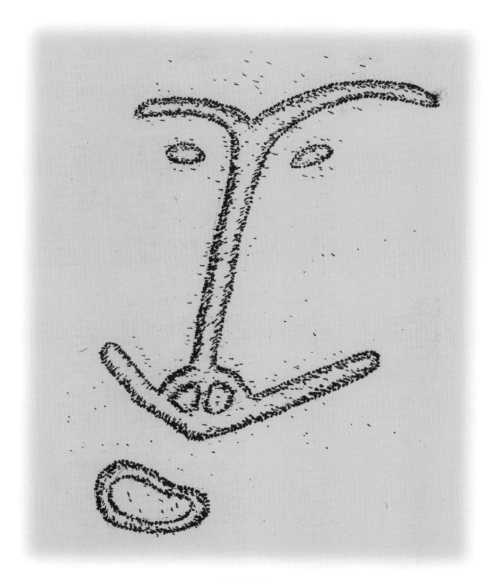

Goldmine Site

ciqluaq) pits overlook the carvings and beach. Situated on the hillside, settled in a bowl, it seems the perfect spot to break the winds yet be able to keep an eye on the petroglyphs and any migrating whales. The shape and size of these house pits—specifically, small single-room houses—leads one to speculate that they were occupied during the Kachemak tradition, anywhere from 3,800 to 800 years ago.

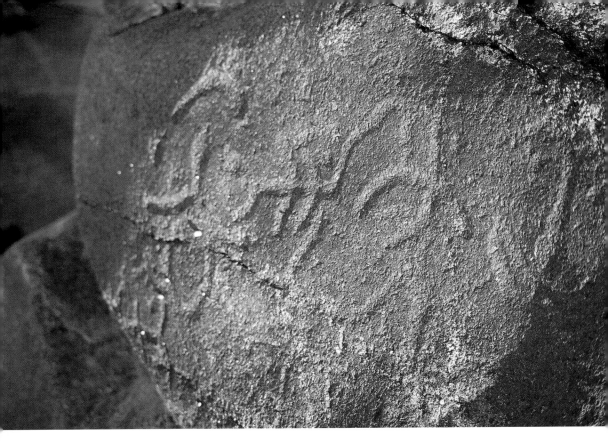

Right: Sea Monster at the Goldmine Site

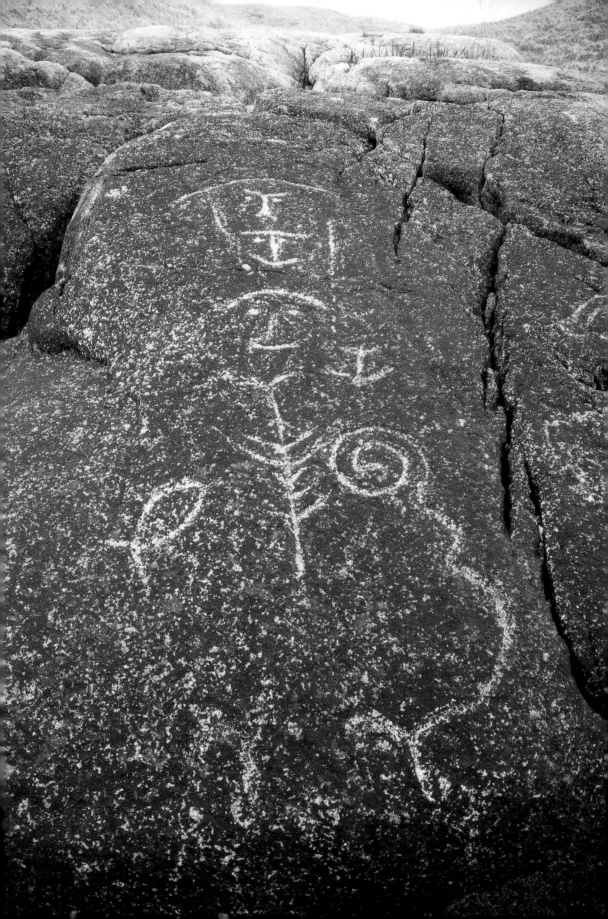

Dwelling requirements included a source of fresh water and a gently sloped beach for landing skin boats. Settlements were prominently located, often at the mouths of Kodiak's major rivers and points of land where inhabitants could watch for sea mammals and monitor movement of other people.

Qiug Akirluni

North Goldmine

The Northern site is separated from the southern by a small cobblestone beach no greater than 50 feet across. They both harbor scores of faces and each has one carving of a whale. That is where the similarities stop. The northern site's main grouping of figures is on a large rock facing out towards Alitak Bay. They range from anthropomorphic faces to geometric designs such as spirals, stars, and some as yet unidentifiable patterns. The most intriguing image is what I call the "Smiling Hands" icon. I realized that this was Sedna, the goddess of the sea, with a hole in each hand to allow some game to escape to ensure future food supplies.

Englaryugluni aigaq

Sedna the Sea Goddess

This carving is probably the most viewed and photographed of the Cape Alitak petroglyphs. Located at the North Goldmine site, this one-of-a-kind symbol is the only face with body parts that I have come across. With five fingers on each hand it is one of the largest single forms at 45.1 cm in height by 48.9 cm in width and an average of 1.7 mm in depth. With a WNW orientation, this symbol shares a granite boulder with many other carvings. Primarily un-outlined faces with one five-rayed star, one counter-clockwise spiral, and other geometric (azoic) designs. Two labrets or lip plugs are predominantly displayed.

I did not realize the significance of this carving until I did a rubbing which produced the above right form. Even then, it wasn't until the day that I met with the school group from Akhiok-Kaguyak, teacher Reneé, Judy and Mitch Simeonoff, Roy Rastopsoff, Willie Eluska, and Dr. Sven Haakanson at the Goldmine site, that another piece of the puzzle slipped into place. As I was showing the group some of my sketches, Sven enthusiastically pointed out that there were holes in the hands. I was aware of that but had not made any connection. The Alutiiq Museum has used several images including this one as a logo/letterhead for the Museum and Repository since its inception. The discovery of the holes added an entirely new dimension to this image.

There are several interpretations of this design's symbolism. The further one studies and researches a subject, the more possibilities the mind puts forth. Also, the more minds focused on a subject the better the likelihood of coming up with a reasonable hypothesis. That is the beauty of the unknown with such phenomena, where not one of the original authors is alive to substantiate or disclaim one's interpretation. This inability to verify a hypothesis helps to perpetuate the mystique of these symbols.

One avenue of thought is that the holes allow travel into another realm of existence. One which the shamans strived to achieve on a physical and spiritual basis.

Another hypothesis, and one with more support from similar cultures such as the Yupik people in the Bering Sea region, suggests that the holes in the hands indicate the spirit's willingness to allow, by impairing her grasp, many animals to slip past the hunters' fingers, thus ensuring the continued abundance of animals in the ocean. Masks collected from the Yupik people and masks collected during the 1800s from Kodiak show similar hole-in-the-hand motifs, indicating that the two groups may be linked. "Sedna," in the Yupik culture, was a spirit sea goddess or sea monster who lived at the bottom of the ocean and was said to have control over the seals, whales, and all other sea creatures. If specific rules were not adhered to and respect for all living sea creatures was not followed, Sedna

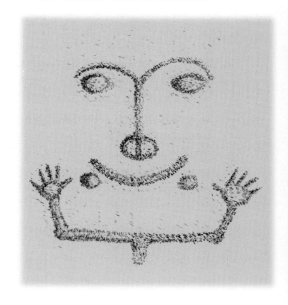

Smiling Hands

would drive away these animals. For a subsistence-dependent culture this literally was a matter of life and death. The spirit of Sedna has been documented across the Arctic and into Greenland.

Similar spirits have the same ability as seen in other carvings and symbols from different areas. One such spirit is "Tunghat" Keeper of the Game from the Bering Sea Eskimo culture. One of the most powerful and malevolent spirits. Artifacts and drawings are often depicted with pierced and thumbless hands.

This rock faces towards Alitak Bay and is partially covered with each flooding tide. The first time that I began recording the petroglyphs in earnest was on this particular rock. As I had just finished with the overall dimensions, I was kneeling near the image and about to use a set of electronic calipers to record the depth of the incisions when a tremendous power emanated from the rock and passed through me. What moments earlier had been a brisk wind accompanied by choppy seas was virtually calm and flat. It was as though I were surrounded by a coterie of faces. Everything was ghost-like, there was nothing tangible that I could describe, almost like wisps of clouds or smoke. The energy lasted about ten seconds. I sat still and let the experience discharge itself. It wasn't a fright-

ening situation but there was no mistaking that this was one to be respectful of. This was my initiation to the energy of the stone.

To be in balance with nature, one should only take what is needed. Show respect to the animal's spirit, utilize as much as possible, and ceremoniously return any unused portion. I have adopted two names for this symbol. Primarily due to the fact that for the many years prior to learning the proper name, I referred to Sedna as "Smiling Hands."

Takuka'aq

Bear

When most people think of Kodiak Island, they identify with the Kodiak brown bear. Bears have always been on the island and are associated with the supernatural. Paleontologic evidence of Kodiak bears has been found in some of the oldest midden sites of the ancient Alutiiq people. The Alutiiq hunted bears, using their meat for food, hides for clothing and bedding, intestines for rainproof parkas, and teeth for adornment.

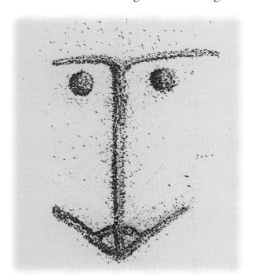

Nothing was wasted. Bears were usually stalked by groups of two or three hunters armed with bows and arrows. The bear arrow was about 32 inches long and had a barbed bone point 7 inches long with an inserted end blade of slate. Before a hunt, it was of great importance to cleanse oneself. The hunters would take a *banya* (sweatbath) and dress in clean clothes in order to hide their smell. Hunters never bragged about their successes because the bear might be listening. If the bear attacked, the hunters defended themselves with spears. Bear hunting has always been a high-prestige enterprise, accompanied by elaborate ritual. It still is today, but the friendlier ritual of the eco-adventurer is to observe or capture these magnificent creatures on film. They are of great value to wildlife managers as an indicator species of ecosystem vitality. *Ursus arctos middendorffi* are long-lived mammals that require large expanses of land to meet biological needs. The Kodiak National Wildlife Refuge was established in 1941 to protect bear and other wildlife habitat. Approximately 3,000 bears live in the archipelago with many more inhabiting the Katmai Coast. The southwest end of the island supports the highest bear densities and approximately 15 percent of the Island's bear population.

They have a lifespan of up to 30 years, but fewer than 20 is the norm. Mature sows weigh in at 350 to 750 pounds, while a large male can reach up to 1,500 pounds. Their hearing is good to excellent by human standards, and their ability to distinguish color and

activity at all levels of light is considered good, but not exceptional. Their crowning glory is best described by this quote from an unknown author: "A pine needle fell in the forest. The eagle saw it. The deer heard it. The bear smelled it."

This carving is located at the North Goldmine site next to the "Smiling Hands" symbol. Although it can be argued that the nose form is seen on human images elsewhere, my first and lasting impression is that of a bear. Even though it is not an exceptional work in terms of creative license, it is of personal significance to me.

As I was measuring the left eye of this petroglyph for depth, water came up out of the rock and splashed me in my left eye. At first I thought that a wave had broken over the rock or water had squeezed up through a crack in it, but the tide was ebbing and very gentle. I felt as though I was being watched.

In retrospect, I believe that the carving was remarkably like a bear and the water that squirted in my eye was an omen that on my next visit I would see water flying out of a rock, and the eyes of a bear would be locked in on me. I feel that the spirits wanted me to clearly understand the power they controlled and their ability to be benevolent.

Almost two months later my family came up to visit. We went by skiff on the outside to the Goldmine petroglyphs. My 12-year-old daughter slipped and landed on a rock at the base of the carvings. The rock that she pulled out from under her had a natural design of a bear on it.

Tunumi lingalaq

Behind the Eye

GEOMETRIC/AZOIC DESIGNS: Many pictographs and petroglyphs appear as geometric designs. These are visionary images that served as "signs of supernatural power." Archeologists call these geometric images entopics (within the eye) because they represent light patterns that are generated by our central nervous system (CNS) during a trance. The human brain dislikes randomness and chaos, and therefore tries to find ways to turn random entopic designs into meaningful symbols.

Entopics occur either by overstimulating or understimulating the CNS. Understimulation causes the CNS to create its own inputs. Overstimulation causes a variety of chemical changes in the body, which also resemble brain activity during a trance.

Whether created through meditation, fasting, rhythmic sounds, or the use of hallucinogenic drugs, there are usually three phases (R. Warms 1997).

PHASE I: Entopic designs. These designs are produced by the physical aspects of brain structure, and as a result are the same for all people everywhere. That is the reason many similar symbols such as spirals, circles, stars, etc. are seen on different continents.

PHASE II: Individual memory. The mind elaborates the designs into familiar patterns. Entopics are present, but they now become part of images of familiar places, things, or people. The content of this stage is highly dependent on individual history and personality.

PHASE III: Cultural symbolism. As the trance deepens, it taps deep cultural symbols. Entopics are still present but they are elaborated into central symbols of the culture. A

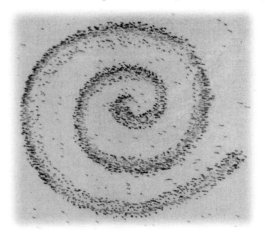 widely understood entopic pattern is the spiral. The spiral is universally accepted across cultures to represent growth and evolution, the transformation of form and essence. Traveling along the spiral, you reach the same points with each round, but at a different level, and with a different perspective.

Spiral markings are associated with the solstice emergence, migrations, whirlwinds, and creatures associated with the water.

Related to the spiral are concentric circles, each representing completeness and wholeness. Like the layers of an onion, we experience ourselves in stages of increasing depth. Believed to represent the whirlwind, both the spiral and concentric circle were thought to carry a shaman into the supernatural. The whirlwind did this by concentrating supernatural power.

Imaq iiyaq

Sea Monster/Devil

This grouping of symbols is located at the South Goldmine site and is one of the largest and most interesting series of carvings. The story surrounding this panel is that a Sea Monster has swallowed a group of unfortunate hunters. This story depiction is an excellent example of the elusiveness of these symbols in general. The photograph on page 79 shows what is generally visible to the naked eye. This is most certainly one site that

greatly benefits from a rubbing and the shadows cast by the setting sun. Initially I surmised that the images had recently been chalked. After careful examination, I determined that the chalked appearance was due in part from tiny barnacles in the grooves and secondly, the patina that covers certain rocks had been chipped through to expose the lighter rock beneath.

It took many visits and many different environmental conditions to fully see (as much as the "Old Ones" allow) the unfolding of a multitude of carvings. Some are relatively evident but the majority appears as a digested ensemble of faces and pieces. The sketch on page 86 was created from a rubbing and it becomes quickly evident that there is more to the story than "scratches the surface."

My first impression was that of a great whale and her calf (a smaller, yet similar shape is to the right). As was the custom, hunters would target the smaller whales because the likelihood of a successful kill was greater. The smaller whales were not as experienced and the aconite poisons used on the harpoon tips would have a stronger effect on the immature central nervous system. The larger sea monster had, doubtless, experienced and escaped many hunts as visualized by the numerous faces and partial faces within the context of her arc. A fish is included, but is fully incised. The faces and transparent bodies of the hunters are indeed being pulled out to sea by the clockwise spiral that leads at the bottom of the panel to a scattering of partial faces, a graveyard of victories perhaps. The smaller sea monster has some elements under its arc but they were not distinguishable via rubbing.

Arlluk giinaq

Killer Whale Face

This combination of zoomorphic and anthropomorphic images bolsters the assumption that the carvers of the stone were completely in touch with their environment. The tail flukes of the killer whale (*orca orca*) continue the lines into the mouth of the face. The spatial orientation of this carving is distant enough from other petroglyphs to eliminate the possibility that space was an issue and they were just coincidental.

Although it seems unlikely that one of the ocean's greatest hunters could fall prey to a man in a kayak with a harpoon, this image may be more for its symbolism. Killer whales have been known to hunt their slower moving cousins such as the gray whale and humpback whale. Both these species frequent Alitak Bay and other Kodiak waters.

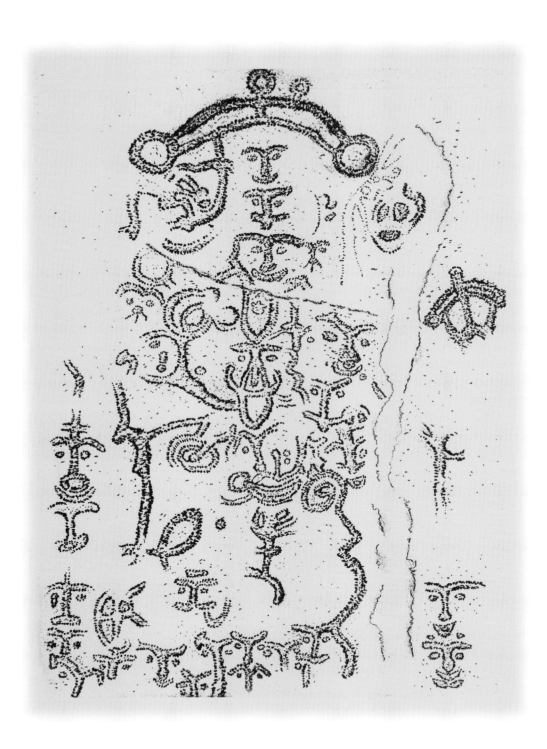

One hundred feet to the south lies another combination chipped in the granite bedrock, this time with a sperm whale (*Physeter macrocephalus*). Its tail flukes continue into the mouth of a face. These are the only two whale carvings at this site and, unlike the whale images at the Cape, are from the suborder Odontoceti, the toothed whales.

Skaapaq giinaq

Ledge of Faces

Looking down on a ledge below the Sea Monster petroglyph, I could vaguely make out some lines in the rock. I had taken numerous photographs at several different times but nothing of any interest evolved. Then one evening, the long shadows of the setting sun worked their magic and revealed a multiform of faces and lines.

The images sparked an interest, but not until I did a rubbing was I privileged to see a rock ledge filled with faces, some superimposed upon the other. This was a spiritual place that was visited often over time, the artists chipping out their visions on any available surface.

One young local man, upon seeing this sketch, started to explain that it was a family tree. Beginning with the larger face, there was the grandfather, grandmother, son, and wife and so on through the eldest son. Other parts could well have been a map of their home or hunting area.

Outlined faces are not found with nonoutlined faces. Quite evident that these carvings were done over a widely spaced period of time and in different techniques.

Iinaq

Faces

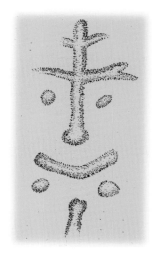

Right: In petroglyph art, attention is focused mainly on heads, which are carved with depth and clarity, while body parts receive minimal attention. The heads are presented from the front and are laterally symmetrical. This particular face has a head ornament and/or some sort of head gear. It is located at the South Goldmine site and even though the grooves have been pecked deeply, it is difficult to see little more than the eyes, nose and mouth.

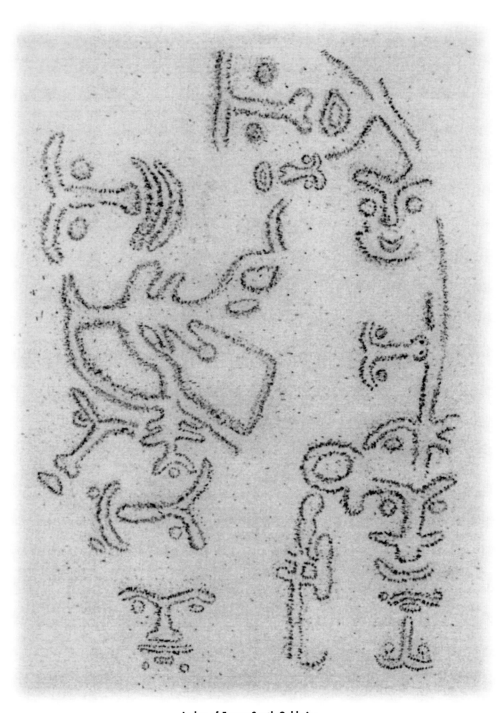

Ledge of Faces: South Goldmine

Right: This face was the first carving that I saw when I came to the petroglyphs a decade ago. Even though this image is carved on granite, the most common intrusive rock exposed to the earth's surface and in general the saving grace in the overall weathering and preservation of the petroglyphs, ten years later this face is recognizable only because I know it is there.

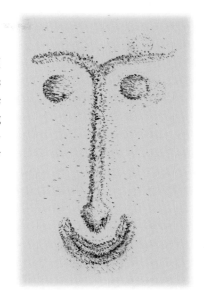

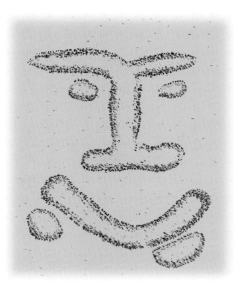

Left: This rather widely grooved face typically hides under a covering of seaweed during the summer months sending its message out with each receding tide. As the seasons change and the weather deteriorates with the fall and winter cycles, the pounding surf cleans the rocks and it is more clearly visible.

Right: This face has three labrets and four adornments above the left eyebrow.

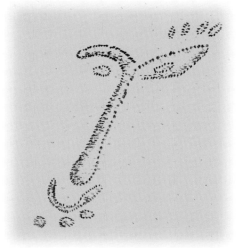

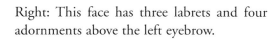

Right: This is a rather adorned face with forehead marking, diaposed rays from the eyes and teeth, or bangles below the mouth.

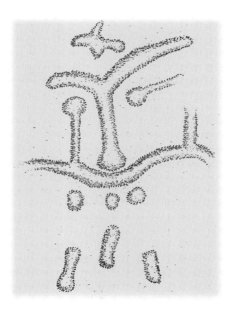

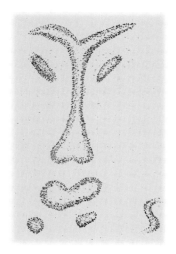

Above: This face shows similar features to Asian and Siberian carvings. Somewhat unusual is the heart-shaped mouth.

Right: A rather adorned face.

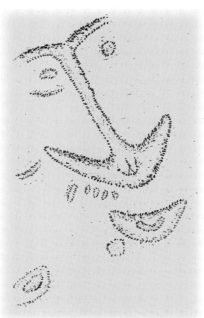

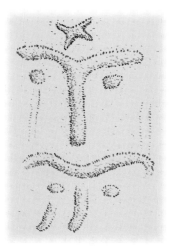

Left: A rather unique image with a double face motif and rays coming from the eyes, it also has a type of head adornment.

Right: The mouth on this face is a little sharper and could be representative of another style and/or another artist.

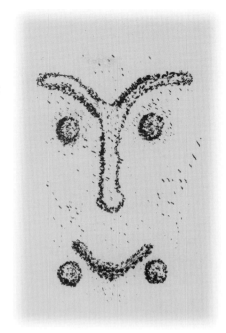

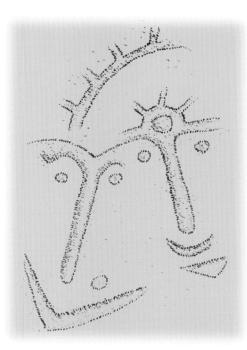

Left: It is relatively common for faces to overlap or conjoin. The style of the nose being straight and long, as opposed to the more frequently bulbous end, is indicative of either a different artist or that of a different culture or a different time period. The rubbing shows a partial view of a headpiece and a more angular mouth than typically seen. The arc with the rays could perhaps be related to a sun deity or similar solar design.

Right: This face shows a more war-like constitution.

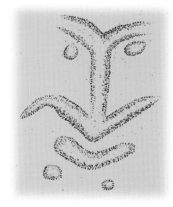

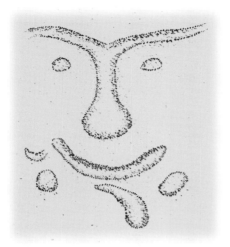

Left: This carving is unique in the fact that it appears to have a tongue. This is very significant, for, by means of tongues, the power of the spirit was passed from supernatural beings to the shaman.

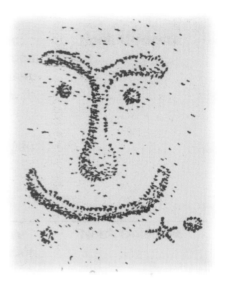

Right: The smiling face comes from the Bear Point site. It is in poor condition and patience was an integral part of collecting this image. Unusual in the fact that this face contains not the standard two labrets, but three, and one of them is star shaped. Located on a more-or-less perpendicular plane, it gazes out towards Alitak Bay and the southern skies.

Below: This series of faces is typical of the abundance of images and spatial orientation. These three friends happen to be in alignment, but many of the rock surfaces are crowded and in many cases overlap.

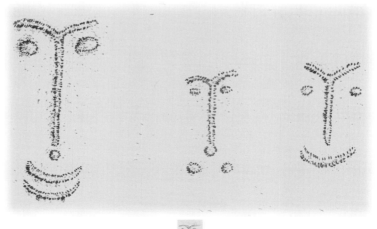

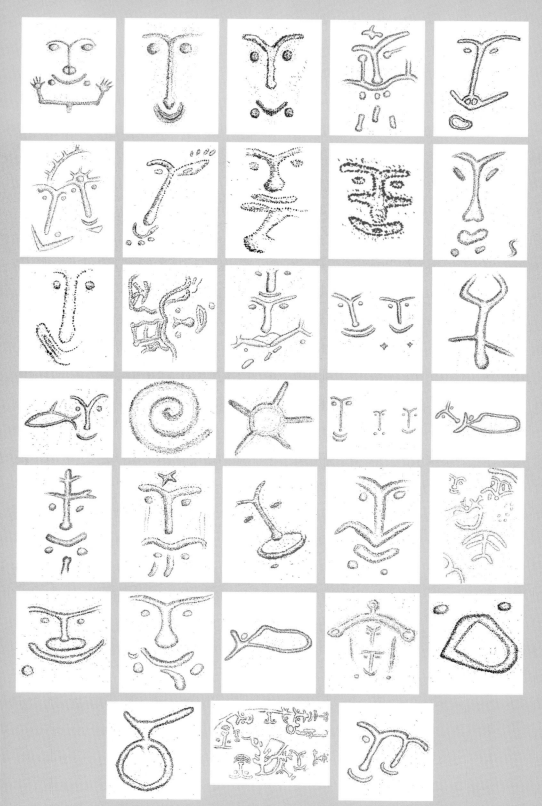

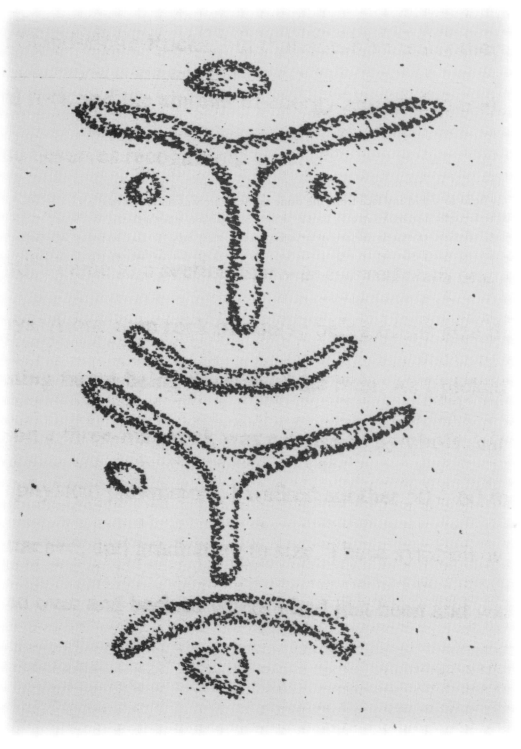

C H A P T E R 1 0

Nangarlluni kesiin yaamaq

Stand-Alone-Rocks

came across these carvings as I was walking the beach early one morning. The wind was bitter cold and relentless. The night had been one of driving wind and rain. As I turned my head to shield my face from the dune sands, there was flash of a face off in the distance. I could just make it out, and as I approached saw another face. Many of these faces remind me of animals in the wild, not because of their appearance but, like most animals, the closer you get the harder they are to see. They tend to disappear, being shy or scared, but still curious. They fade out of sight and reappear as some distance comes between you and them. Like so many of the carvings, I previously had looked closely at these rocks, seeing nothing but the natural imperfections. I suppose that when your spirit has spent eons in the stone, there's not much need to rush out and show one's self to a stranger. It could be argued that this small aggregation of symbols does not constitute a site. My feeling is that

Nangarlluni: stand up
Kimmi // kesiin: alone
Yaamaq: rock
Discovered 5-20-01
6:31 A.M. (2) faces

if there is a break in the continuity of symbols and/or a physical break in the geography, then that classifies it as a new site. Two symbols are all that I could see at Stand-Alone-Rocks, but that doesn't mean others were not hiding. Because of the physical nature of the hard rock and the amount of energy required to make a symbol that would last countless ages, I feel even one deserves recognition.

I continued up the beach in a northeasterly direction until I came to a section that was littered with one- and two-man rocks. I use the term from my wall-building days. A one-man rock of course being of the size that could be handled into place by one man. The mitigating factor was the size of the man. As I picked my way through and balanced from crest to crest, there on a three-man rock was a series of symbols that would have to be rubbed to be discernible. After recording its physical parameters, I walked another 50 to 60 feet, turned around, and spotted a series of diamond shapes, all attached, and graduating in size. These symbols were on a significant boulder. Climbing to the top, I peered over and back to where I had just been and was treated to two rock panels covered with

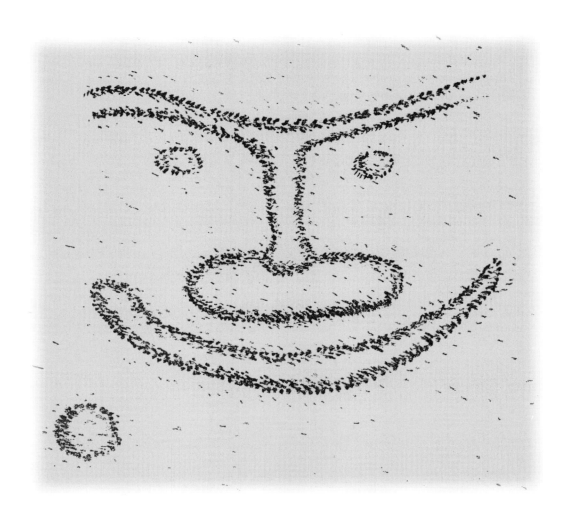

CHAPTER 11

Takuka'aq cingiyaq

Bear Point

The sixth, seventh, and eighth petroglyph locations are further down the beach from the Goldmine sites. By following the gently curving beach easterly for a little better than one-eighth of a mile, you will come to a large grouping of rocks. They present themselves as an ideal setting for carved symbols. However, I have scoured these rocks many times but have not found anything. As I mentioned earlier, during all my scouting around the headlands and beach rocks looking for any solitary carvings, I found only one: well-weathered, half-buried face carved on a wave-smoothed rock looking out to sea. Early on in this project, I came to the realization that once I started looking for petroglyphs, every crack and stain in any rock I looked at exploded with visions. Most were soon dispelled, or if uncertain, I would try to capture it on film. More than once I got the film back only to find a rock.

This particular rock that I am referring to is one that I must have passed by several times and in retrospect, even thought to myself "that looks like the right kind of rock." As with many of the symbols, they stare out at you but it isn't until the setting sun delivers its longest rays, that the spirit is visible to the mortal world. That is how I came across the "Bear Point Keeper." I was walking away from it when I thought I heard something. I stopped, turned, and literally watched the shadows transform into a face. That was a gift from the "Old Ones."

Bear Point is a name that I came up with the first time I found these sites. I was dropped off on the beach at what I thought could be a potential site. As I saw the skiff fade from sight, I became painfully aware of my isolation, which seems somewhat unusual considering the number of times I had done this and especially since I was always adamant about coming by myself. If you flip to the back of the book and read Appendix III, you will have a better understanding. In brief, two months earlier on my way to the Goldmine petroglyphs, I was stalked and charged by a Kodiak brown bear. I saw plenty of spirits that night.

So here I am, first time back, walking on the beach, feeling apprehensive at best. It was an invigorating, clear September evening, the setting sun in full glory, so bright that I had the brim of my hat tipped over my eyes and even had my hand outstretched to shield some of the blinding rays as I walked towards the sun. I could hardly see ten feet in front of me. I remember clutching my pistol (the same one I had left home last encounter) and thinking to myself, "I'm going to walk right into a bear." Well, I didn't

actually walk into one but I looked up on the bank 50 feet above me and there was a thousand pounds of fur-enshrouded muscle staring down at me. My heart skipped a beat as I stopped dead in my tracks. *Ursus arctos middendorffi* looked at me, sniffed the air a few times, and turned away. What seemed like several minutes in all probability was just a few seconds. Now the next hurdle: where he had been is where I wanted to go. With pistol poised and singing in my loudest tenor voice I climbed the bank. Once I was on top and everything looked as normal as could be expected, I looked back over the edge towards the water and was treated to a rather compact, smooth, and level platform with a handful of faded images.

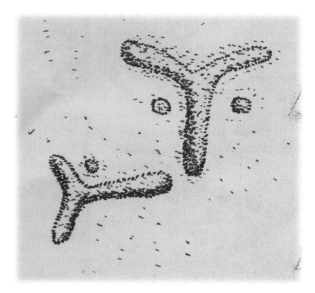

After documenting these carvings I moved westward along the bank maybe 100 feet and found nine more carvings: five partial faces, including two each with two labrets, one was very well defined; one circular form; and three greatly faded images that even after rubbing were still indiscernible. These sites had a peaceful quality about them. In comparison to the Cape and Goldmine locations, the two sights melded together. Smaller in area and higher in elevation, the images were more or less carved on a horizontal plane. My thoughts were that both would have been ideal lookout points for spotting the live animals and being able to see the floating corpse after they were dispensed. It appears that my friend thought the same thing.

I have walked the shoreline and scoured the rocks, where practical, from Rodman Reach, past Rudy's Rock [a longtime Alitak fisherman], along the Cape, around the Goldmine, Bear Point, and beyond, with the hopes of finding some sort of physical connection. Since there was at least one solitary carving between the sites, maybe there were more sentries or messengers connecting all the locations. Unfortunately, I have been unable to find such a correlation.

May 13, 2001, was Mother's Day and what an evening it was—absolutely beautiful. One additional image stands out in my mind. I had walked past the headland that juts out towards Rudy's Rock each time I visit the petroglyphs and had even climbed over the rocks looking for any signs. As I was passing, I thought that I should look again but decided to keep going. As I have matured with age I have come to the fork in the road where if something is on my mind and it is realistically achievable, I will stop and do it. As I turned back, a wave broke and curved around the side of the promontory. There it appeared before my eyes—a six-rayed star. I now can verify a symbol at each end of the Alitak Cape arc of carvings, another gift from the "Old People."

May 19, 2001

Changing hats once again, I must add the following story. I was invited by the Akhiok-Kaguyak High School class to help map out some of the petroglyphs and to share some of my work. It was the first time that I had the opportunity to spend several uninterrupted hours at the different sites. I was in heaven. Usually, it would take about one hour for the skiff ride and hike just to get to the petroglyphs and another hour back. That would leave me one or two hours to collect data, which is the elusivity of the quarry. Well, as providence would have it, the barometric pressure plummeted and a southeastern ravaged the coast. Most would think that this was a stroke of ill luck, but to me it was a blessing in disguise. I wasn't able to go back to base camp tonight and I would have to spend the evening surrounded by the images that fascinated me so. The temperature dropped, the wind worked with a vengeance, and the rain seemed to be auditioning for a part in Noah's ark. Since I hadn't planned on spending the night, I was looking for a rock ledge to offer some shelter, dressed in my Stearn's work suit. "Fisherman" offered his one-man tent. My body weight was the only thing that kept the tent from blowing away.

After a virtually sleepless night, I literally found myself at the Goldmine site, huddled behind a huge rock at 5:20 in the morning. Trying to find some respite from the wind and rain, I pressed closer to my refuge, opened my field notes, and stoked up the cigar I had partially enjoyed only a few hours prior. Taking full advantage of my luck, I began a focused, systematic survey of what lay before me. Lady Luck was on my side, so it seemed. There was a minus tide, which aided in my being able to attain an entirely new perspective.

Before my very eyes, faces began to appear like small children coming out of hiding, curiosity getting the best of them. Rocks that only yesterday I had walked over and in all likelihood leaned against, exploded with images everywhere I scanned. It was a reference in time that transcended the past and the present. I had reached an epiphany where the spirits had let their invisible cloak fall, signaling to me a new chapter of acceptance.

All tolled, I had the distinct honor of locating forty-six new carvings, mostly stylized faces. Most images were vaguely evident, but evident long enough for me to record. One of the rocks I had leaned against to have a bite of lunch yesterday, showed signs of workmanship. After rubbing, a series of faces were revealed.

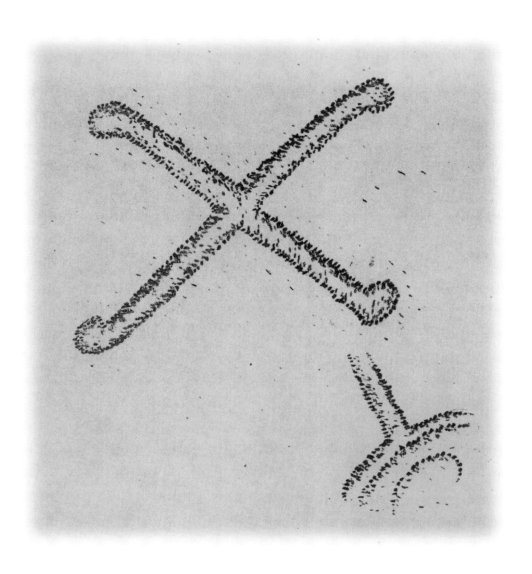

CHAPTER 12

Awaten ang'aluni

Etiquette

There can be no compromise in protecting these fragile and priceless resources. Archaeological sites are protected by the Antiquities Protection Act of 1906 and the Archaeological Resources Protection Act of 1979 (ARPA).

Petroglyphs may seem as durable as the rock they reside on, but care should be taken to preserve them. Even though the Cape Alitak petroglyphs are carved in granite, invariably deterioration will occur by natural causes. The abrasive effects by environmental factors such as wind and rain, freezing and thawing, and the relentless pounding of the surf will slowly obliterate what man so diligently has spent time creating. Unfortunately, modern man is probably a petroglyph's worst enemy. While nature slowly works its natural course, a few moments of thoughtlessness by man can erase what has lasted hundreds, and in many cases thousands of years.

- Stop, look, and think before entering a cultural site.
- Enjoy rock art by viewing, sketching, and photographing it.
- Never chalk. Although it is popular to chalk and relatively harmless, it attracts attention from those less likely to have an appreciation for the carvings.
- Creating modern rock art is known as vandalism and is punishable by law.
- Cultural sites are places of ancestral importance and should be treated with respect.
- Never touch, spray water, chalk designs or use paints on petroglyphs.
- Do not walk on petroglyphs.
- Never leave trash at sites. They are religious places to Native Alaskans and should be treated the same way we treat our churches.
- If you see others vandalizing sites or accidentally hurting the art, please report to the local authorities. In this case, call Akhiok-Kaguyak Tribal Council: (907) 836-2229.

As you approach a site, take pause to feel the energy of the stone. It isn't just about the carvings, but the rock itself. The shaman had to come to a fixed place, a power center to use its particular energy. This was home. When you go, leave these portals to the spirit world just as you found them, so that others seeking answers can speculate about them in like manner.

A picture is not only worth a thousand words, it speaks across a thousand years. Petroglyphs are not just inert remains of lost cultures, but are instead, dynamic, surviving components of those cultures. Whether they are family symbols, ceremonial markings or doodling, one thing for certain, they are not replaceable.

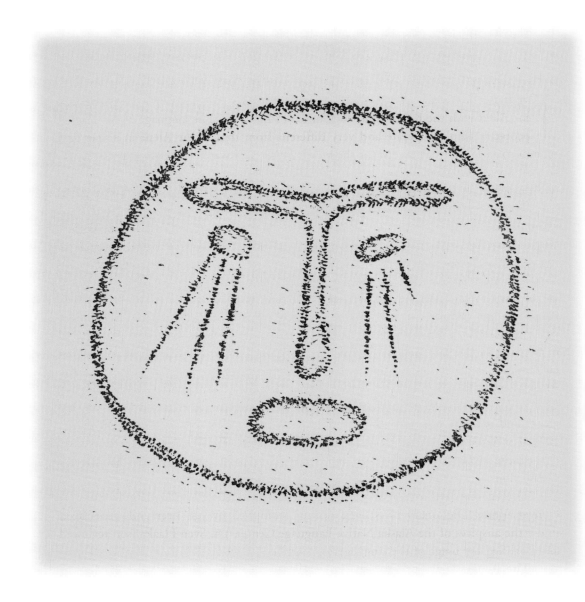

C H A P T E R 1 3

Niuwaciq/yuuwaciq

Language

The first actual study of the Koniag language is owed to Veniaminov. He compared the Aleut with the Koniag and concludes (1840, 2:4), "The language of the Kadiak people is wholly separate and very different from that of the Aleut in affixes and names, so much so that except for the words father and water, there is no resemblance; but the structure of the two is quite one and the same."

The important differences are that the Aleut language has a sound which the Koniag has not; and while the Aleuts can count to over 10,000, the Koniags can count only to 200, and in a wholly different way.

> All inhabitants
> of the Kodiak Archipelago
> speak the same language,
> with only small differences.
> —Davydov 1810, 2:1

The term *Alutiiq* refers to the language and people of the Pacific Eskimo region of the north-central Gulf of Alaska. "The Alutiiq people consider themselves Aleuts and not Eskimos, even though they share a common ancestry with the Yuiks, and their language is related to the Yupik. A member of the Eskimo family of languages, Alutiiq is split into two dialects: Koniag Alutiiq, which encompasses Kodiak Island and Perryville, Chignik, Port Heiden, Pilot Point on the Alaska Peninsula, and Chugach Alutiiq, which is indigenous to Port Graham, English Bay, Seldovia on the Kenai Peninsula and Prince William Sound. The term is relatively recent and is the term preferred by the Native people of this region, over either *Pacific Eskimo* or *Koniag* (both used in varying contexts in the past). Kodiak Alutiiq are a subset of the more widespread population inhabiting the southeastern Alaska Peninsula, Kodiak, and sections of the Kenai Peninsula.

The chapter headings and other native spellings used in this text come from "A Conversational Dictionary of Kodiak Alutiiq" compiled by Jeff Leer and Irene Reed under the auspices of the Alaska Native Language Center. Dr. Sven Haakanson reviewed and qualified my usage of the language.

The Alaska Native Language Center held a week-long workshop in Kodiak in January of 1978. The fundamental expectation was to introduce the Alutiiq writing system to key people within their villages. People such as elders and Tradition Bearers who did language work and would strive to keep the ways of the past from fading away.

CHAPTER 14

Mulu'uuk

Tools

George Emmons in 1908 noted that two types of petroglyphs are clearly distinguishable on the northwest coast. One is deeply carved and consists usually of combinations of cups, rings, and spirals. These are invariably smooth-finished, and are considered to represent use of the "pecking and crumbling" technique. This is accomplished by pecking a series of holes and then joining the dots, so too speak, by crumbling the ridge between. In this manner the lines are smoothed.

The other has shallow grooves which were made by pecking but not smoothed by crumbling. They depict recognizable objects in a naturalistic manner. The distribution of the two overlap but are not altogether coincidental; the naturalistic style of petroglyph carving has a more northerly occurrence than the one which is deeply carved and is composed mainly of symbols.

The petroglyphs at Cape Alitak in most cases have shallow grooves and depict recognizable anthropomorphic (human) and zoomorphic objects (sea mammals) in a naturalistic style. The images at the Goldmine site are deeply carved and consist mainly of anthropomorphic (faces) and azoic symbols. Although there is some overlapping at each site, it is evident, or at least plausible, that these carvings could have been done in two widely spaced periods and two different technique styles.

Although no specific tools conclusively relating to petroglyphs have been found around Kodiak, the accompanying photograph shows a stash of local greenstone that I strongly believe was used to fashion the carvings. These handheld stones show battering on one end, both ends and around part of the perimeter. Whether used in the stone-pecking process or for utilitarian purposes, one thing is certain, they were used for some manner of heavy percussion.

Joy Inglis, in her book *Spirit in the Stone,* recants the foreword by an Kwulasulwut Elder of the Nanaimo Band on Vancouver Island. "Petroglyphs are gifts from the Creator who gave shamans sheer energy to go into the rock, their fingers hot with a power like electricity. It was not the body that could do all these things but the soul, the spirit; not the person but the other self, the extension of self." This suggests that the tools were merely a conduit for the true power which came from the "spirit" within.

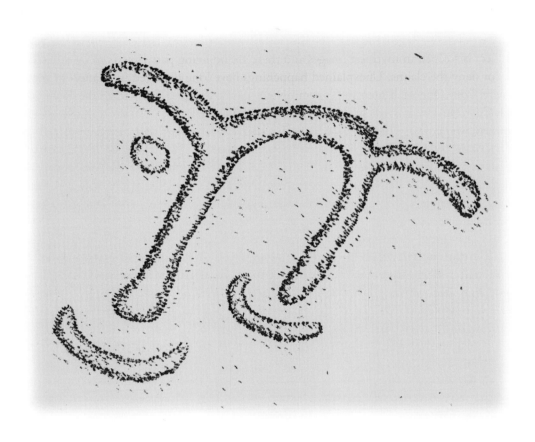

CHAPTER 15

quliyanquaq

Folklore/Myths

The unknown is good fodder for speculation and folklore. Especially when the subject is steeped in mythical images and there are no living participants to substantiate or deny the claims. Unexplained happenings have long occurred in relation to these ancient sites. One such mention is reminiscent of the Sargasso Sea within the Bermuda Triangle. Countless numbers of vessels that fish or travel through Kodiak waters have experienced unexplained interference with their ships navigational instruments. Their autopilot and compass begin to act strangely as they approach Cape Alitak. The compass's magnetic setting to true north has been seen to spin out of control and the autopilot refuses to keep a true course. The pilot of a local cod and dungeness crab boat, the "Point Omega," claims that this occurrence is a common event as he nears the Cape. One possible explanation could be the area's rich abundance of magnetite in the dune sands, which is a natural magnet and a main component of iron oxide (Fe3O4).

The harbinger of bad luck will follow anyone that walked on a petroglyph and if an uninitiated person walked in front of or came across a sacred petroglyph place, they would be killed—harsh treatment for such an indiscretion, but then those were harsh times and respect of the spirits was paramount to survival. There is no record of this occurring on Kodiak Island; however, it has been claimed that this was not an unheard of occurrence farther south—Point in particular, off the coast of British Columbia and Washington.

During a conversation with Mary Peterson, I mentioned that I had felt a power at the Cape. She told me that the power had been felt before. Many years back, in 1916, Simeon Agnot and three others became weathered in at the Cape. During their stay the power was very evident, enough so that the frightened men pushed their heavy wooden dory across the beach to an inside route and as soon as they felt they had a chance, tackled the seas to fight their way back home.

During a visit to the sites with the Akhiok-Kaguyak school we found two shaman barabaras on a hilltop overlooking the Cape. As we stood near the depressions, Judy Simeonoff and I looked at each other. We both had the hair on our necks standing straight out. That was a different type of energy. When photography first appeared in the late 1800s, a primitive person's fear of the photograph was very real. They believed that some of the life or power of the subject was stolen with each image.

There has been reported a petroglyph of a mother with child. I did not find any evidence of this but speculate that the Sea Monster carving at the Goldmine site may have

been characterized as such because there are large and small carvings of similar design on the same rock.

Legend has it that the 1964 earthquake and previous strong shocks knocked parts of the petroglyphs into the water. I had full intentions of donning my scuba gear to try and substantiate this rumor, but either the timing or weather interfered with that plan. This only adds to the mystique of the area and offers hope of yet another chapter to the story.

Legend also claims that there are several caves within the area that house the mummified remains of great whalers. I did look for such, but did not find any. My search continues. I believe that all folklore, rumor, and legend initially began with some semblance of the truth. That over time and allowing for human nature, and multiple interpretations, the facts may have been altered to accommodate the individual storyteller. If these stories could all be substantiated, then the curtain of mystery would be lifted and man would have nothing to satisfy his natural curiosity. That is not the case with the Cape Alitak petroglyphs.

E P I L O G U E

iqukllilluni

Petroglyphs are man-made images which are abraded, carved, incised, pecked or scraped into a rock face using crude tools. Made for various reasons, but all related to early Native religion, these sites are a fragile but evocative legacy. I am sure that there are numerous petroglyphs that have evaded the countless attempts I have made to wrestle them into my visionary world. Each time I went in search of them, the environmental conditions were different and the intensity and angle of light was ever changing. Quite often making even the recognizable symbols appear altered or difficult to find. Rubbings revealed a multitude of symbolic figures, at times far more than I ever expected. In contrast, rubbings also brought forth non-sensible lines and images that were undistinguishable.

> We are indebted to the ancestors of the Alutiiq people for leaving us a storybook in stone. These sites are sanctioned places where the spirits gaze out through the thin veil of granite separating the two worlds.
> —Woody Knebel 2000

The essence for most communication, symbolic representation, allows cultures to pass on great amounts of wisdom from one generation to the next. Symbols borrow from experience and become individualized through the creative method of the artist, whether it be visionary or religious. Others, with a greater breadth of understanding, may have come up with entirely different impressions than I have. Anyone can surmise as to the specific meanings behind each symbolic representation since not one of the original authors is around to verify or dispute that interpretation. Any serious conjecture is worth mentioning. I feel that I have accomplished what I originally set out to do. That is, to collect data, document it, and put forth as clear a depiction of how the Cape Alitak petroglyphs appear today—to bring to light this foundation of Alutiiq communication that has sat silently for untold years. In no way does this diminish the power or uniqueness of the region or the traditional qualities that brought these people together for a transmission of their beliefs and intervention with their spirits. Unique among artifacts, these petroglyphs are just that, artifacts which have not been removed from their original locations. When you stand in front of them, your feet press the rock where the carver once worked, you can smell the ocean air and feel the salt spray on your face as he did. Then if you wait long enough, the slanting rays of the sun will deepen the shadows in the uniquely carved rock surfaces to help raise the lines of antiquated art depicting supernatural outlines. The animistic belief that everything has a spirit must have served the early Alaskan well. Rock art is the only artifact that required the maker to observe the environmental process, assimilate the information through his mind, and then express it back out in any shape or form he desired. It is the only artifact

that lets us look into the mind of the person who creates it (Keyser 1992, 138). Rock art was, and still is, the link to the spirit world.

Since the early part of the last century, anthropologists have been probing and studying the regional archeological record. Thus far, they have gone back more than 7,500 years in the prehistoric past of the Pacific Eskimo culture. The largest concentration of petroglyphs within the Pacific Eskimo/Alutiiq-Sugpiat territory is at Cape Alitak. As presented, one can see that they are characterized by anthropomorphic figures, geometric or azoic symbols, and zoomorphic images. Of the 511 different symbols I have located, I have detailed 200 or so carvings within these pages. Of those 200, approximately 65 percent are anthropomorphic (having human features) in style. Included in this group are masks and faces as well as the obvious forms. The majority of images however are stylized faces encompassing approximately 65 percent within that group. The geometric or azoic category contains 12 percent and the balance, and 23 percent conforms to zoomorphic (animals and birdlike) tradition. The effort that has gone into this book has come from the heart. The sense of purpose I began with has only grown stronger with each journey to the sites. One of my goals was to tell this story in a dignified and respectful manner. *Quyanaa cuuliraq* (thank you) to the "Old People." Your children's children's children can contemplate these images in the stone. From this they can take a deep, prideful look at their heritage and perhaps reach their own spiritual connection. The countless hours in the field amid Kodiak's ever-changing weather patterns along with the experiences that ensued throughout this whole process have, in themselves, been personally fulfilling. My work is for the Alutiiq people and my hope is that if even a single "Young One" finds spiritual affiliation from my efforts, my labors will have been fruitful. I have been vague on the location descriptions in part, to honor a request from the Alutiiq people, and in part from my own feelings of discovery. If one is truly interested and respectfully motivated, then by handing them a detailed roadmap to the symbols, in my opinion, would only devalue the thrill of personal accomplishment.

Castun uksurtuluni ellaita qelluugluku

How old are these symbols?

That is the most frequently asked question of me. No one really knows; the elders are buried who did these things. I suppose it depends upon your perspective. Do we really want to know? Would that change our perception of these antiquities? That is the beauty of the unknown with such phenomena, where not one of the original authors is alive to substantiate or disclaim one's interpretation. The inability to verify a hypothesis helps to perpetuate the mystique of these symbols. Man's self-imposed lordship over nature leads us to believe that we can modify the unknown to accommodate our curiosity. But in all candor, if a symbol is produced by an unknown culture and interpreted by anoth-

er group centuries later, is its true meaning unveiled or is it further obscured? Very little hard, factual evidence has been accumulated in regard to the meaning and purpose of petroglyphs in general. As a result, we may tend to grant them a greater age than they probably warrant. However, there are several hypotheses and comments that I have come across in my research that lead me to speculate as to an age of these images in stone. Heizer postulates that "the petroglyphs on Kodiak and Afognak Islands could be assigned to the Koniag archaeological phase; that, late pre-contact up to the early 19th century" (AD 800 to mid-1700s). Assuming that the Kodiak petroglyphs are derived from early Northwest Coast petroglyphs, they must have developed after other Northwest Coast art forms. The rather elaborate totemic designs on many southeastern glyphs point to a fairly late date; hence, a late date is assigned to the Kodiak glyphs as well.

Heizer and Clark (1964) compared Alaskan petroglyphs with other Koniag art forms which have been found *in situ* (the place where something exists or originates) in archaeological sites and can be dated with reasonable accuracy. Compared were the many incised slate tablets and figurines found by Hrdlička at the Uyak Bay site (1931–1936) and by Clark (1960; 1964) at various locations near Kodiak. Clark found several hundred of these artifacts and was able to confirm that the incised stones were confined to Koniag phase contexts, appearing to be fairly short-lived (AD 1300–1500) in extent (Clark, 1964, 121). These figures, whose use is unknown, are incised to depict human facial features and clothing. Many elements in the tablets, such as "minimal face," are similar with those in the Cape Alitak and Afognak Island petroglyphs.

It is probable that the Koniags made some petroglyphs; but the islands they occupied and their rocks were not favorable for the art, and there is no reference to the subject in the older records. There are numerous and excellently made petroglyphs on Cape Alitak. A note was published by the Alaska Packers Association in 1917 (*American Anthropologist*, 19: 320), but the natives of the region know nothing about them; nothing like it is found anywhere else in the Koniag region, and they may well have been of pre-Koniag origin (Hrdlička 1944, 67).

Dr. Donald Clark identified a Kachemak tradition at three sites on Kodiak Island: Old Kiavak, Three Saints Bay, and Crag Point (Clark, 1966a, 1970a, 1975). The Kachemak tradition succeeds the Ocean Bay phase and has a time frame of 1500 B.C. to A.D. 1200. Lasting in the neighborhood of 2,700 years, it was characterized by new tool forms and the development of art, particularly in the Late Kachemak phase, including labor-intensive and visually stunning stone lamp relief carvings and the use of body ornamentation (labrets) made of high-quality, nonlocal materials (Steffian and Saltonstall 1995). A high percentage of the stylized faces at all the sites have one or more labrets. Although this is not conclusive, it does offer a possible time frame for the inclusion of labrets into the art form.

The Koniag phase of Kodiak prehistory directly follows the end of the Kachemak tradition and extends to the first establishment of a Russian settlement on Kodiak in 1784. Koniag sites are often large and are common throughout the archipelago. Multiple-

room pithouses are found in the Koniag sites and are typically three times the size of the Katchemak mean (Donta 1993, 17). Without extensive excavation, at first impression the single-roomed barabara pits found above the Goldmine petroglyphs could fall into the Katchemak tradition timeline.

Black (1987, 7–50) states that the method of poisoned-dart whaling was a prehistoric antiquity on Kodiak Island. It was possibly as old, or older than, the Ocean Bay II phase (2500–1800 B.C.). This phase began approximately 4,500 years ago and lasted a few centuries. There are several whales portrayed throughout the sites that could be attached to this time frame.

I feel that all the sites have a spiritual quality about them, each with its own individual aura and energy. The Cape sites seemed to have more ceremony associated with them—the rock outcrops forming a natural arena for intervention with the spirits of the animals of prey—a receptacle for directing the food supply to enter the more protected waters of Alitak Bay, where a hunter could realistically approach one of the behemoths and get close enough to cast a poisoned-tipped harpoon. On a bluff overlooking the Cape are two shaman barabaras.

The Goldmine sites generate an intense energy and seem to be troubled. Perhaps that is where the actual division of the catches (butchering of the animals) took place. The adjacent beach provided an excellent place to land an animal of enormous size and was relatively protected. I feel a greater sense of movement. There is definitely more spiritual energy around. Directly above the petroglyphs are several Kachemak-era housepits (barabara). Probably between 800 and 3,500 years old (1500 B.C.–A.D. 1200). This was a significant dwelling site and gives credence to placing an age on the carvings. Stand-Alone-Rocks has a passive feel to it. When I see the two faces, I envision children on the rock enjoying the freedom of youth.

The Bear Point site had a gentle, non-violent atmosphere. From all the faces and its vantage point, it could easily have been a lookout. Overlooking both Stand-Alone-Rocks and Bear Point are a multitude of larger, multiple-room housepits (barabara sites), indicating a substantial population inhabited this area.

Entrance to this great "object" where the sea breaks its back, could have been accomplished via the Bering Land Bridge and in all likelihood by the use of small, skinned craft to cross the short distance between the place where the Asian and North American continents approach. This distance is a mere 55+ miles. Over thousands of years, recurrent migration of small, different groups brought with them a diversity of languages and corporeal types. Once on the Aleutian chain, the groups broke up into the northern Bering Sea (Pacific Area) Eskimo and the Kaniagmiut (Koniags) that continued to the east and south where they found quite livable conditions within the Kodiak Island Archipelago

It is quite plausible that these symbols could have been carved over a widely spaced period in time, using different techniques and different artists. Once a suitable site that met all the criteria had been found, it was revisited over time. Different carvers utilizing available space, drawing spiritual and social influence from the energy of the stone.

Based in part on research, but heavily weighted on my personal feelings after spending a significant amount of time with these silent messengers, I feel the carvers came from the mid Kachemak tradition (1500 B.C. to A.D. 1000) and continued into the Koniag culture (A.D. 800 to A.D. 1300) periods. This would put the Cape Alitak petroglyphs at an equitable, yet undefinable age of 700 to 3,500 years old—more sensibly in a magnitude of 700 to 2,000 years old.

In the future there may come to light, extended or newly recovered carvings. Hopefully, they will be respected and shared, so that these treasures can be appreciated for what they are, icons of a past race of people. Knowledge is insignificant if it cannot be mutually experienced. Rock art is a material artifact from a non-material realm that can tell us something about how ancient people viewed their world and gave it notice.

These sites are about people who survived in a unique environment through their belief system. To the Native, geography was more fixed. The strongest message in rock art is the rock itself. Pecked into the rock is the story of those people who gained the knowledge and understanding of their world through that system. It is a story of survival. Some say the symbols that have become too weathered to distinguish are a sign the spirits have left that place. Although I felt that certain carvings were more powerful than others, I never subscribed to that philosophy. Just spend some time with the symbols and if you are receptive to the energies encompassing these sites, you will agree that their presence is still evident. These carvings are an intriguing legacy of their earlier presence even though the meaning of the figures is unknown.

From the dim beginnings of art when it had a purpose, to today, when a resurgence of cultural pride is making great strides to recapture the connection with the "Old People," the Cape Alitak petroglyphs continue to stand a silent vigil, sending out their message with each receding tide.

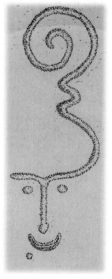

Iqukllilluni quliyanguaq umyaaqlluku

The end of the story.
Remember it.

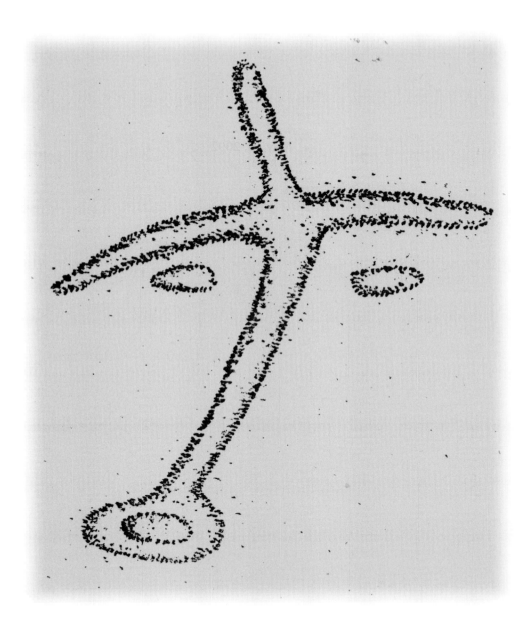

T E L L A S T O R Y

Quliyanguarluni

May 19, 2002
8:00 P.M.

Sitting on a ledge above the North Cape site
Watching the spirits come and go
as the setting sun angles lower to the horizon
Smooth granite rock bare
Slowly a face appears and just as slowly fades away
A myriad of faces cautiously watch
But two are intently watching me high on my perch
I have seen these two before . . . but briefly
For they are sly ones
The others come and go
But tonight my two friends linger
I climb off my ledge to capture an image
As I approach they fade away
When I am again seated above, I turn to see my two friends
The granite canvas is clear now save
Two sets of eyes and a partial mouth.
Ancient figures, silently calling out messages,
the words of which are forever inaudible

A P P E N D I X I

Quiliraulluku

Explanations for the Petroglyphs

The reasons and explanations for the existence of petroglyphs are as varied and provocative as there are styles. As I progress through the writing of this book, I have encountered varied opinions as well as superstitions in my research. The following have either been related to me personally or have been referenced throughout various publications.

". . . No one knows for sure, therefore any hypothesis is at the least essential, worth mention."—Aleš Hrdlička 1932

"From the old people"—Captain C. A. Halvorsen, Superintendent of the Alaska Packers Association cannery at Alitak, 1917. This is the standard answer received when inquiring among the neighboring Koniag.

"The symbols were ancient carvings of an unknown race"—An elderly native about eighty-five years old from the village of Akhiok when interviewed by a Russian priest. He declared that neither his father nor his father's father had ever heard any traditions connected with them. 1917

"The carvings were left as notes to the next person to come along. So they could read what had gone on before them. Which way the fish had gone . . . what time of day they had gone on their hunts . . . things like that."—Mary Peterson, a "Tradition Bearer" from the village of Akhiok

The petroglyphs were created "before animals were transformed into men."—Harlon I. Smith, Archaeologist, related to him in 1920 by Native people

"Our rocks are evidence of the Creator's gifts. They are there to pass on this knowledge to anybody who studies them."—Ellen White, Kwulasulwut Elder, Nanaimo Band, Vancouver Island

"The function of petroglyphs was to record specific mythological animals."
—Recording of a myth, a Bella Coola Indian on the Noeick River

"Product of a stranger people who in travelling along these shores, before their existence, made such signs to guide them on their way in returning or in again going over the ground."

"The elders can say . . . those who have gone before left this record so that you can understand."—Alfonso Ortiz, Native American, Professor of Anthropology

"Made to cause rain."—Haida informant

"The petroglyphs were placed where the tide would submerge them in order that the fish would hear the message of the carved figure."—Coastal Natives for whom salmon was the basic food resource

"Petroglyphs were carved to mark the boundaries of family hunting territories."—The Coast Salish as told to H. I. Smith

"They were made by a race that was here before the Indians, and all knowledge of their meaning had been lost."—Nanaimo Band Indian who had taken Mr. Mark Bates, the first white man to see these antiquities in 1860, to the site on Vancouver Island, British Columbia, known today as "Petroglyph Park"

"A place of power used by Shamans' for training initiates."

"They highlight places of power."—Greg Colfax, a tribal artist of Neah Bay, Washington. The most consistent explanation of why petroglyphs were made relates them to the sea, pools, rain, and rivers, frequently salmon-spawning rivers.

"Rock art was a link to the spirit world."—James Keyser, Archaeologist with the U.S. Forest Service

"The old Indians declared it was a product of an age of which they have no record."—Nanaimo Community Archives, taken from a newspaper article dated May 26, 1926, in reference to the Hepburn stone, the oldest evidence of Native art on Vancouver Island

Doodlings of primitive man—Keithahn, 1963

"Shaman and medicine men made rock art to preserve a record of their visionary trances. Shamans used fasting and native tobacco to enter a trance during ritual vision quests. These were believed visits to the supernatural, where the shaman obtained supernatural power, often in the form of animal spirit helpers." —BLMCA

"Marking a sacred place."—Joy Inglis, *Spirit in the Stone*

The symbols carved upon the rock are the Shaman's "spirits." This is the "spirit" of the stone.

"Messages from the old ones."
"The rocks that teach."
"The symbols grew there with the rocks."
"They are messages from the old ones."
"Ancient graffiti . . . doodlings"
"Power-filled rock face"
"Whiling away time waiting for the tide to change."—Joy Inglis, *Spirit in the Stone*

"Powers that hint at the power of calling in the wealth of the sea."

In all non-human forms, apparently inanimate, such as boulders, the original pre-transformation form lies dormant. This is the unseen "spirit in the stone." Petroglyphs were sometimes made as a record of slaves sacrificed at potlatches.—Tlingit people, as told to Laguna

"If a chief gave an important ceremony, he or one of his friends carved a petroglyph of a man or an animal connected with the ceremony, to recall the event."—Bella Coola Indian to McIlwraith

An elderly Indian informant from Agate Point reported that when she was small she was warned by her elders not to walk in front of petroglyphs. At the Tastsquam site near Bella Coola was the meeting place for a secret organization, and that an uninitiated person would have been killed for trespassing there.—The Bella Coola people told McIlwraith

The Bella Coola petrogylphs were carved by a family secretly singing sacred songs, pecking in time to the music. This information seems to relate to Newcombe's statement that those seeking spirit power made pictures of "the spirits with which they held communion."

"Some petroglyph sites are the places where the shamans spent time fasting and training"—Beth Hill

"Connected to fertility rights"

"An ancient artform used by many cultures as a means of personal expression and tribal identity."

"Rocks tell creation story."

It has been suggested that this place was the scene of ancient ceremonials, possibly by a people who paid homage to the sun, for the first rays of the rising sun would strike directly upon the spot and that the split boulder may have served as an altar.—Nanaimo Community Archives, C5, B1, F13

Many pictographs and petroglyphs appear to be geometric designs. These were visionary images that served as "signs of supernatural power." Archeologists call these geometric images entoptics (within the eye) because they represent light patterns that are generated by our nervous system during a trance. Animal figures were animal spirit helpers; human designs were images of the shaman or other human-like spirits seen in the vision. Because the shaman was believed able to change into his spirit helper while in the supernatural, some motifs show a human transforming into a spirit animal. —BLMCA

Local storytelling rock/celestial calender—Sanilac

The 'Nlaka'pamux and their Stl'atl'imx neighbours believe that the oldest rock writings in their territories date back to the Mythological Age, having been created by the land and water mysteries, or by the Transformer beings.—Teit 1906, 275; 1918, 5

Rock art may have mnemonic devices (meaning assisting memory) used to record events.

The Zuni believe that the oldest stone symbols were produced by their ancestors to convey messages to later generations.—Young 1990, Smota 29

A P P E N D I X I I

Tukniluni

The Power

May 31, 1999
6:08 PM
at the Goldmine Site

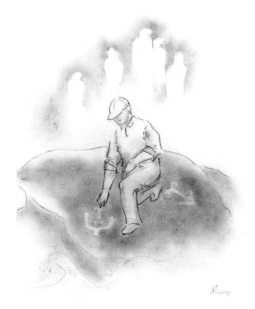

This was the second excursion of the season that I had made to the petroglyphs. A week earlier I had given them a cursory look and tonight I was armed with camera, notepad, compass, tape measure, and a set of electronic calipers. It was a typical Kodiak evening, overcast and bitter cold. The seas were moderate.

Having left camp almost one hour ago, I began this evening with a 30-minute skiff ride up Rodman Reach. Securing the skiff and walking to the Goldmine site accounted for the other half-hour. As I walked by the boarded-up gold mine, I envisioned an earlier era when this was an active operation. I half ran to the base of a cliff spilling onto the beach. Climbing a narrow deer trail to the top of the knoll, I then picked my way down through the beach grasses and lupines to the black granite rocks. Once at the petroglyphs, I immediately set about my work by recording a geometric design, that of a counterclockwise spiral. It was a relatively small image measuring approximately 8.5 by 7.75 inches. I had been thinking of this day all winter. After completing the spiral, I then moved over and slightly higher on the same rock to measure two faces that were a little bit larger but in poorer condition. One of the faces had been pecked below the mouth to signify labrets.

I then moved down to a deeply incised face with arms, hands, fingers, and labrets. It was the only one of its likeness that I had seen. I would later come to call this carving "Smiling Hands." The cobblestones rolling in the surf below with each pounding surge, added to the mystique of these symbols and created an uncanny sound that seemed all encompassing.

As I was kneeling on the boulder measuring, I felt an extraordinary sense of power emanating from the rock, so intense that I felt an energy go through me. It was as though I were surrounded and being watched by a coterie of eyes. After a few moments I realized

this was more than an ephemeral lapse of time. The tactility was similar to the tingling one feels when their leg has fallen asleep. Different though in its intensity and fluidity. The circle was incomplete, with the side facing the water being crowded, best described as fragile wisps of clouds. Although there was nothing tangible, what came to mind were thoughts of apparitions.

The wind began to blow harder, the waves intensified, and a bone-aching chill permeated the air. The antiquated wooden case that held my measuring devices started to rock violently, even though it was resting on a relatively level plane. I did the only thing I could, I stayed still and experienced the moment. I had been anticipating some sort of sign from this project. It wasn't a frightening situation but there was no mistaking that this was one to be regardful of.

After collecting myself, I continued on with my work. Next I moved slightly down and eastward to a bear-like face. As quickly as the wind and waves had heightened they calmed down. I was now looking at a relatively horizontal sea surface and directly in front of me a kittiwake was repeatedly diving into the water and coming up with small fish. They looked like sand lance, a slender silvery fish 3 to 4 inches long. The tide was receding quickly. I even unzipped my jacket.

While most would try to distance themselves from this place, I found it even more intriguing. Anxious to experience more, I moved scarcely a foot eastward to what appeared on first impression like a bear's face. Quickly noting the overall dimensions, I lay down on the rock to measure the depth of the piercing left eye. Almost immediately, a squirt of water came out of nowhere and hit me squarely in my left eye. The water must have traveled up a crack, seemingly coming from the rock itself. Startled, I bolted upright and cleared my eye. I felt a sense of laughter surrounding me.

After I had documented twelve glyphs on the primary Goldmine site I moved southeast to the next outcropping. There I documented nine exceptional examples. Like many of the others, these carvings were directly exposed to the open ocean, standing out more so because the lines were encrusted with what I believed were small barnacles. There were many more faces but vaguely visible. They would have to be rubbed to discern them.

The weather had improved considerably so I took the opportunity to sit on the rocks and enjoy a cigar. As I did, I could see in the distance several whales blowing and occasionally breeching. I pictured myself back to the days of the carvings. The shamans and hunters probably had been sitting in the exact same spot watching for the whales. Then the wind picked up and the bitter cold returned.

All one needs to read the spirit in the stone is an open mind and heart and a willingness to at least listen to things that would at first, appear foreign. Those with a closed mind will never experience the power surrounding us from past souls. These symbols are messages to the spirits and those able to listen.

The "Old Ones" had given me a glimpse of their presence, power, and their sense of humor.

Iingalaq takuka'aq

Eye of the Bear

had been traveling by skiff for almost twenty minutes, on my way to Cape Alitak. This 5-mile trip from the cannery at Lazy Bay on the south end of Kodiak Island was in turn close to 100 odd miles by floatplane from the town of Kodiak. I fought the ebbing tide up Rodman Reach, named after Lieutenant Rodman, chief navigator and surveyor on the U.S. Navy steamer *Albatross* who in 1899 along with Commander Jefferson F. Moser (Moser Bay) was charged with the duty of exploring and examining the streams and lake systems of Alaska, so far as related to salmon and other fisheries.

After another fifteen minutes, I rounded the southern arm of the reach, catching a glimpse of the granite headlands that would put me in touch with the mythical world of a past civilization. Although research and documentation of these ancient carvings was my goal this evening, I was unaware that a much greater adventure was in store for me. Life has a peculiar way of getting your attention and little did I know that before long all my collective senses would be focused. As I approached the head of the reach, I noticed a gillnet boat, the *Shadrack* and a set net skiff anchored near where I planned on beaching my craft. It was the first time I had seen other people up here on my many excursions.

After securing the anchor I started walking on the leeward side of the spit, heading through a small channel towards a long-abandoned gold mine. The weather that day had been unusual by most standards but this was Kodiak. Beautiful and calm when I awoke at 4:30 AM, followed by mist, rain, fog, sunshine, wind and more rain. The early evening sky was settling into a light drizzle with a biting breeze, a normal day in these parts.

Through the beach grass I could just catch a glimpse of the bones of the old, Best

caterpillar that must have hauled the black sand to and from the mine's centrifugal separator, standing a silent vigil. I felt in my pocket, reminding myself of the cigar I looked forward to having. As I looked at the scene unfolding in front of me, I made a mental note that this could be a potential photograph with the right lighting. The sky was enveloped in an inauspicious low overcast but I decided to forge ahead regardless. Because the tide was usually in when I came here, this was not my normal route.

Once through the rocky outcropping and onto the shallow tidelands, I came upon a single large rock out in the middle. It was the size of a small table, or in retrospect, a small altar. I jumped onto the rock and paused for a moment, always ready to absorb the peace and solitude I found in Alaska. With nature's boundless primeval harmony playing in the background, I took a deep breath and thought to myself what a wild and beautiful place this was.

Suddenly, I heard a splashing through the water from behind a wall of rock. I could see the water flying. Although I couldn't see it, I knew instantly that it was a bear. It was a familiar sound to me, that of bears chasing salmon in Olga Bay, up the Dog Salmon River. Instantly, it was there, a huge bulky Kodiak Brown. He stopped on the edge of a rock and watched me from about 30 feet away, his eyes locked on mine. Although I tried not to stare into his eyes, some primeval instinct drew me into his soul.

I froze. Every recollection and bit of sage advice that I had ever heard about bears reeling through my mind. Don't run, stand still, walk away slowly, play dead, make noise. I was also painfully aware of the .357 magnum Smith & Wesson that I had chosen to leave in its case back at camp. I certainly felt like carrying it now. I vividly remember palming the ivory handles and spinning the chamber as I admired the gleaming stainless steel. It's funny the things one remembers at a time of crisis. I put down my knapsack, took out my camera, and took a couple of photos with my Canon camera. I would later joke about not having my Smith & Wesson but I did have my Canon. I am a nature photographer, and it seemed like the natural thing to do. After capturing these once-in-a-lifetime images, I habitually turned off my camera, put the lens cap back on, wrapped it up in a fish embroidered bandana, secured it in my knapsack and then slowly got down from the rock, hoping now that we could go our separate ways. As I moved, the bear moved with me. I stopped, he stopped. I took another step back, he in turn took another step forward. I tried this three or four times. As I did, he followed me, crossing his front paws as a cat would. He hunched down, I could see the fur bristling on his hump, all the time eyes locked on mine. My fur was bristling too. He began to get closer, gain on me, lowering to the ground like a lion stalking its prey. At about 10 feet away, I thought of charging him. I had read somewhere that if you "fake charge" a bear before he charges you, your chances of survival increase. However, not being a gambler, would I yell and scare him away or yell and make him attack me sooner? I was aware I was shaking, especially my right leg. If I had stood there long enough, I would have dug a hole. I was not particularly scared. It all seemed like a dream, only in slow motion.

Time appeared to be frozen. I thought to myself, this is how it happens. In one split second your life is forever changed. It was at this moment that an overwhelming revelation came over me. I thought of my family and bent down to get my camera once again from my knapsack. I was aware that I was becoming lower to the ground, perhaps a submissive instinct. He was about 5 or 6 feet way, eyes burning a hole through mine, ready to lunge. I held up my camera, fumbling with it as I tried to take a picture, my mindset being that in the final analysis, my family would at least know what really happened. He towered over me and I prepared for the crushing blow. All the while continuing helplessly to click a shot. For a moment all was calm. It seemed as though I was waiting for the crescendo in an operetta.

Suddenly, he spun around and raced away. Gravel, seaweed, and water exploding in the air and on me. I was covered. Out of reflex, I fired a couple of rounds from my trusty Canon as he raced away.

This huge creature seemed to reach the summit of a 200-foot bluff in a matter of seconds. My recollection was one of awe at the speed and power of this one animal. It took me a few seconds to realize what had just happened. What made him change his mind? It certainly could not have been me. Then the sickening option that something behind me, perhaps a larger bear may have scared it away. I turned around, half expecting to see a larger bear. Instead, nothing but wide open space. Hallelujah!

I dropped to one knee and said a quick "Thank you God." Getting up I made the conscious effort to slowly remove myself from the scene. I could see the bear in the distance still heading away but turning to look at me every few steps as I did him. The next 100 yards were agonizingly slow. However, I felt some sort of comfort the closer I got to the petroglyphs, regardless of the fact I knew that I would still be in the middle of nowhere. Those rocky outcroppings were my refuge.

With each step I was becoming more cognizant that my breathing had slowed as I was still holding my breath. I was also aware that my shaking had increased exponentially. Relieved to have reached the carvings unscathed, I felt for the cigar in my pocket. Skipping the ceremony of cigar etiquette, I bit the end off and stoked it up. Before the cloud of rich blue smoke had dissipated, I had already begun to document a couple of symbols. One ironically resembled the face of a bear. But the thought of that big bear coming over the ridge left me anxious. The cigar did nothing more than aggravate the situation. I soon found myself ready to move on; strange how fear sanctions scientific work.

Reluctant to go back the way I had come, I followed a bear trail, the honest truth, along the undulating granite ridge of the peninsula towards Cape Alitak. Twenty minutes of stumbling over the deep-rooted, age-worn trail got me to my next refuge where once again I tried to document another set of carvings. I think I was looking for anything to take my mind off what had just happened. I did find some consolation in the 80 or so symbols that lay before me but after a few minutes realized that I needed to get home. My senses were rapidly returning as I walked back across the tundra towards the skiff. This circuitous route added a couple of miles to my trek but the alternative of going back

124

the same way I had come was less appealing. I brushed past the arctic lupines and monkshood, careful not to step on them, thinking how thankful I was to be able to enjoy their beauty.

Once I reached the crest of a knoll overlooking the main beach, it took all my self-control not to burst into a dead run for the boat. I could see a beach fire and stopped by to warn the people about my recent experience. Meanwhile the tide had receded even further and my skiff was high and dry. Even though the adrenaline was still coursing through my veins, I gratefully accepted help from the group to push my boat back into the water. As I was poling out into deeper water, I realized that the wind was pushing me shoreward and that I had been downwind of the bear. I do not recall smelling or hearing anything except the splashing of the water.

It wasn't until I was back at base camp and telling my family and friends about my encounter that I truly appreciated the gravity of the situation. I also realized that ignorance can be comforting. In retrospect, I believe that as I was fumbling with my camera, my habit of replacing the lens cap after each image, saved my life. While trying to take the cap off, my finger hit the shutter release which triggered the low-light indicator mechanism. This emitted the life-saving red strobe light and beeping sound which startled and caused this one particular Kodiak brown bear to hightail it away.

I definitely was spared. I strongly believe that the carving at the Goldmine Site looked remarkably like a bear and the water that squirted in my eye just a week before, was an omen that on my next visit I would once again see water flying out of a rock, and the eyes of a bear would be locked on me. Only this time it wasn't an apparition. Maybe the "Old Ones" who carved the petroglyphs felt that their story hadn't been told yet. Maybe it was to give me an insight or vision as to what they had to deal with in their everyday life. Maybe they just felt sorry for me. Whatever the rationale, I am left with the profound realization that the reason for living is best glimpsed at the edge of death and disaster.

G L O S S A R Y

Aboriginal: being the first of its kind present in a region and often primitive in comparison with more advanced types

Abraded: rubbed or worn away by friction

Aconite: the dried tuberous root of a monkshood plant, very poisonous, used as a sedative

Acumen: keenness and depth of perception, shrewdness

Alutiiq: refers to the language and people of the Pacific Eskimo region of the North Central Gulf of Alaska

Amaranthine: undying, does not fade

Animism: doctrine that the soul is the vital principle of organic development, attribution of conscious life to nature and natural objects, belief in the existence of spirits separable from bodies

Anthropomorphic: described or thought of as having a human form or human attributes

Anthropology: the study of man in relation to distribution, origin, classification, and relationship of races, physical character, environmental and social relationships and culture

Archaeology: the scientific study of material remains as in fossil relics, artifacts and monuments of past human life and activities

Archipelago: an expanse of water with many scattered islands

Artifact: a simple object (as a tool or ornament) showing human workmanship or modification

Auspices: kindly patronage and guidance

Azoic: having no life, of or relating to the part of geologic time that antedates life

Bidarka: a portable boat made of skins stretched over wood frames and widely used by Alaskan coastal natives and Aleuts

Baleen: whale bone, horny plates attached to the mouth of whales in the Suborder Mysticeti, functioning as a strainer of krill

Barabara: sod-covered structure built partially underground

Beringia: the northern land bridge that once connected Siberia with Alaska

Cetacea: an Order of aquatic mostly marine mammals including the whales, dolphins, porpoises, and related forms

Conventionalized: lacking originality or individuality

Corporeal: having, consisting of, or relating to a physical material body

Entopic: within the eye

Ethnology: the science that deals with the division of mankind into races and their origin, distribution, relations and characteristics

Geoglyphs: images formed on the ground (intaglios)

Geometric: relating to, or according to the methods or principles of geometry

Graywacke: a coarse dark gray sandstone or fine-grained conglomerate composed of firmly cemented round fragments, as in quartz and feldspar

Greenstone: any of numerous usually altered dark green compact rocks (as diorite)

Hieroglyphs: written in, constituting, or belonging to a system of writing mainly in pictorial characters. The picture script of the ancient Egyptian priesthood

Holocene: recent

Humanities: the branches of learning having primarily a cultural character

Hydrosphere: the aqueous envelope of the earth including bodies of water and aqueous vapor in the atmosphere

Hypothesis: a tentative assumption made in order to draw out and test its logical and empirical consequences

Incised: having a margin that is deeply and sharply notched

Indigenous: having originated in and being produced, growing, or living naturally in a particular region or environment

Intaglio: an engraving or incised figure in stone or other hard material depressed below the surface of the material so that an impression from the design yields an image in relief

in situ: the place where something exists or originates

Littoral Zone: zone between high- and low-water marks

Medium: a material or technical means of artistic expression

Mesozoic: an era of geological history including the interval between the Permian and the Tertiary and marked by dinosaurs, also relating to the system of rocks formed in this era

Midden: refuse heap, kitchen

Mysticeti: suborder of Cetacea, baleen whales

Odontoceti: suborder of Cetacea, toothed whales

Oecumene: an ensemble of related peoples integrated by trade, migrations, warfare, and the cross-fertilization of ideas, oral traditions and art into a large cultural universe

Outcropping: the part of a rock formation that appears at the surface of the ground

Outlined: a line that marks the outer limits of an object or figure

Patina: a surface appearance formed naturally by long exposure

Pecked: a quick sharp stroke, that leaves an impression or hole

Petroglyph: man-made image, which is abraded, carved, incised, pecked or scraped into a rock face using crude tools

Photosynthesis: the formation of carbohydrates in the chlorophyll-containing tissues of plants exposed to light

Pictograph: image that is drawn or painted on a rock face, normally without pecking or abrasive methods

Shaman: a priest who uses magic for the purpose of curing the sick, divining the hidden, and controlling events

Shamanism: a religion of the Ural-Altaic peoples of northern Asia and Europe characterized by belief in an unseen world of demons and ancestral spirits responsive only to the shamans

Stylized: represented or designed according to a stylistic pattern rather than according to nature

Subsistence: a source or means of obtaining the necessities of life

Symbiotic: living in beneficial partnership

Tsunami: a great sea wave produced by submarine earth movement or volcanic eruption

Zoomorphic: relating to, or being a deity conceived of in animal form or with the attributes of an animal

BIBLIOGRAPHY

Naqlluku

Abbott, Donald. Foreword in *Indian Petroglyphs of the Pacific Northwest,* by Beth and Ray Hill. University of Washington Press, 1974. (Abbott is Curator of Archeology, British Columbia Provincial Museum.)

Alaska Humanities Forum. "The State Theme and Mission Statement." 1998, 5; 2000, 1.

Alaska Packers Association. "Petroglyphs on Kodiak Island, Alaska." In *American Anthropologist* 19 (1917): 320-322.

Alutiiq Museum and Archaeological Repository. Website Education Series: 1998–2002. www.alutiiqmuseum.com

Clark, Donald. "Petroglyphs of Afognak Island, Kodiak Group, Alaska." In *Anthropological Papers of the University of Alaska* 15[1] (1970): 13–17.

_____. "Koniag—Pacific Eskimo Bibliography." In *National Museum of Man* series 35 (1975): 1-28.

Cunkle, James R., et al. *Stone Magic of the Ancients.* Phoenix: Golden West Publishers, 1995.

Davydov, G. I. "An account of two voyages to America by Russian Naval Officer [1810]." In *The Anthropology of Kodiak Island* by Aleš Hrdlička, 1944.

Duff, Wilson. *Images Stone b.c. Thirty Centuries of Northwest Coast Indian Sculpture.* Saanichton: B.C.: Hancock House Publishers, 1975.

Donta, Christopher. "Koniag ceremonialism: An archaeological and ethnohistoric analysis of sociopolitical complexity and ritual among the Pacific Eskimo." Dissertation, Bryn Mawr College, 1993.

Emmons, George. *In Indian Petroglyphs of the Pacific Northwest* [1908] by Beth and Ray Hill, 1974, University of Washington Press: Seattle, 1974.

Emmons, George Thornton. *The Tlingit Indians.* Seattle: University of Washington Press, 1991.

_____. "Petroglyphs in Southeastern Alaska." In *American Anthropologist* 1908: 330-331.

Fitzhugh, Ben. "The Evolution of Complex Hunter-gatherers in the North Pacific, an archeological case study from Kodiak Island, Alaska." Dissertation, The University of Michigan, 1996.

Fitzhugh, W., and A. Crowell. *Crossroads of Continents: Cultures of Siberia and Alaska.* Smithsonian Institute Press, 1988.

Fitzhugh, William, and Susan Kaplan. *Inua: Spirit World of the Bering Sea Eskimo.* Smithsonian Institute Press, 1982.

_____, and Valerie Chaussonnet. "Anthropology of the North Pacific Rim." In a collection of essays by the "Crossroads of Continents" symposium participants, edited by W. Fitzhugh and V. Chaussonnet, 1994.

Heizer, Robert. "Aconite Poison Whaling in Asia and America." In *Bur. American Ethnology Bulletin* 133 Anthropology Paper 24, 1943.

_____. "Petroglyphs from Southwestern Kodiak Island, Alaska." In American Philosophical Society 91 (1947): 284–293.

Hill, Beth, and Ray Hill. *Indian Petroglyphs of the Pacific Northwest.* Seattle: University of Washington Press, 1974.

Hrdlička, Aleš. "The Anthropology of Kodiak Island." In *The Wistar Institute of Anatomy and Biology* 1944: 1-114.

_____. *Alaska Diary 1926–1931.* Lancaster, Penn.: The Jacques Cattell Press, 1944.

Inglis, Joy. *The Spirit in the Stone.* Victoria, B.C.: Horsdal & Schubart, 1998.

Keithahn, Keith. "The Tools of the Petroglyph Mason." In *Proceedings of the Fourth Alaskan Science Conference 1953*: 250–252.

Keyser, James. 1998 – "Dream Grows of Relocating Ancient Petroglyphs." Oregonian Paper, Archaeologist for the U.S. Forest Service." www.oregonian.com, 1998.

Meade, Edward. *Indian Rock Carvings of the Pacific Northwest.* Gray's Publishing, 1971.

Moser, Jefferson. "Alaska Salmon Investigations." Bulletin of the United States Fish Commission, 1900.

Sauer, Martin. An account of a the geographical and astronomical expedition by Commander Joseph Billings in the years 1785–'93, in *The Anthropology of Kodiak Island* by Ales Hrdlička. Philadelphia: The Wistar Institute of Anatomy and Biology, 1944.

York, A., et al. *They Write Their Dreams on the Rock Forever.* Vancouver, B.C.: Talonbooks, 1993.

Note: *Quyanaasinaq* to Alfred Naumuff and Rick Metzger for enlightening me with their local knowledge.

Note: Aerial photographs made possible by David Hilti and his Bird Dog Observation Plane, 2002.

THE AUTHOR

Awaryugluni

Woody Knebel was born near Mt. Edgecombe on Baranoff Island in southeast Alaska to missionary parents. He was the first non-native child born at the new Alaskan Native Service's Hospital, where he received a life-saving transfusion of Tlingit blood. Woody attributes in part, this act of fortune, to his love of Alaska and all it encompasses.

At the age of one, his family was commissioned to the jungles of South America where they set up a Lutheran mission near the borders of Argentina, Paraguay, and Uraguay. With the Missione's jungle as a backdrop, Woody fit right in with the indigenous Guarani people. Once the mission was firmly established, the family uprooted again and moved a world away to a small farming community in rural Alberta, Canada, for another mission calling.

When Woody was twelve, his family moved to Vancouver Island just off mainland British Columbia. It was here in the sheltered waters of Cordova Bay that he listened to his heart and set the course towards an adventuresome life. While paddling an old cedar canoe, he encountered a gray whale and her calf. For a boy who'd just come from the jungles of South America and more recently from the prairies of Alberta, the saltwater encounter was unique. Shadowing each other for more than an hour, the boy and whales made a bond that would last a lifetime.

Woody studied marine sciences at the University of Victoria and spent most of his free time diving around the myriad of Gulf Islands. Many years were spent in Bristol Bay, Alaska, where he worked side by side with the Y'upik people. The next assignment led him to a turn-of-the-century salmon cannery at the south end of Kodiak Island. This placed him directly on the aboriginal lands of the Alutiiq people and their ancestors—the creators of the Cape Alitak petroglyphs.

Realizing early man's total integration with nature, Woody continues to pursue his interest in Native American ethnology, natural history, and photography. Reflecting the spirit of the Native community, he has published many of his unique experiences and accompanying dramatic photographs throughout the years. Woody divides his year between Mercer Island, in the state of Washington, and the Emerald Isle of the north, Kodiak. Woody's dedication to preserve, for future generations, the spirit of the rock is evident by his earnest devotion towards this endeavor.